IMAGES
of America

GERMANTOWN

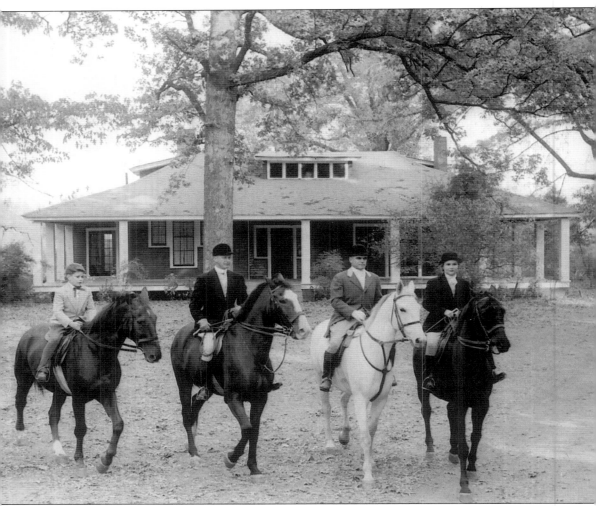

This is a 1952 picture of Oak Grove Hunt Club's new clubhouse on Germantown Road. The home originally belonged to Capt. C.J. Hanks, a steamboat captain on the Mississippi River, and was later owned by his daughter, Mrs. Bruce. The following are pictured from left to right: George McCormick, Walter "Sonny" Foster, Claude McCormick, and Mrs. Dana Brown.

IMAGES
of America

GERMANTOWN

Russell S. Hall

ARCADIA

Published by Arcadia Publishing
an imprint of Tempus Publishing Inc.
Charleston SC, Chicago, Portsmouth NH, San Francisco

Printed in Great Britain

Library of Congress Catalog Card Number: 2003111560

For all general information contact Arcadia Publishing at:
Telephone 843-853-2070
Fax 843-853-0044
E-mail sales@arcadiapublishing.com
For customer service and orders:
Toll-Free 1-888-313-2665

Visit us on the internet at http://www.arcadiapublishing.com

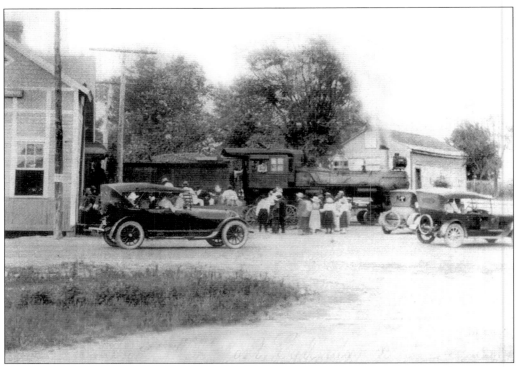

Citizens at the old Germantown Depot meet the train as it comes in from Memphis in 1905. The old depot was the gathering place for the townspeople in those days.

CONTENTS

ACKNOWLEDGMENTS

The author, Russell S. Hall of Germantown, Tennessee, wishes to thank and recognize the following individuals and organizations. I also apologize to each individual or group that I may have omitted due to error. It is both a pleasure and an honor to locate and present these photographs to the public in general. I hope you enjoy this book as much as I have enjoyed creating it.

Marsha Tindall Adkins
Ray Allen
Julie Burrows
Mr. and Mrs. Joe Brooks
Floy Bright
Bess Barry
Jim Cole, Special Collections, University
 of Memphis
Mr. and Mrs. Harry Cloyes
Mrs. Jewel Clark
Nancy Chute
Leola Davis
Harriett Kimbrough Davis
Mrs. Jack Erb
Emma Jean Farnsworth
Ed Frank, Director of Special Collections,
 University of Memphis
Mr. and Mrs. W.N. "Sonny" Foster
Murray Foster
Betty Finger
Carroll Russell Fay
Camilla Lane Gotten
Germantown Chamber of Commerce
Germantown Historical Commission
Germantown Historical Society
Germantown High School
Germantown Public Library Staff
Mrs. Ingram Howard
Mr. and Mrs. Reeves Hughes
Mr. and Mrs. Howard G. Hall
Peggy A. Hall
Ruth Howard

Lewis Allen Jones
Julia Lane
Ethel Lane
Alio Lunati
Mrs. John Kirby May
Dr. Gordon Mathis
Kay Sandlin Miller
Bart and Mary Mueller
Mrs. F.W. Morris
Boyd Maize
Jim McGehee
Sam Oakley
Mr. and Mrs. Jack Owen
Helen O'Brien
Andy Pouncey, Germantown City Administrator
Mary Agnes Prescott
Dr. William E. Renthrop
Bill Skinner
Vernon "Sonny" Short
Festus Scott
James Scott
Nadia Strid
Dan Tindall
Mrs. W.L. Taylor
Mrs. Arthur Thorsburg
Luci May Thompson
Mary Ann Kimbrough Vollmer
Mrs. Walter D. Wills, Jr.
Walter D. Wills III
Flora Warren
Mr. and Mrs. Joe Wright

INTRODUCTION

William Twyford, Germantown's first settler, traveled to the area in 1825. Also in 1825, Miss Frances Wright, a social reformer from Dundee, Scotland, purchased 2,000 acres of land on both sides of the Wolf River; she named her new experimental colony Nashoba, the Indian name for "wolf." Wright's concept was to educate and emancipate slaves. This was a most unpopular venture for the time period and not without defeat, but not before Miss Wright freed and transported 30 of her slaves to Haiti. Twyford and Wright were followed a few years later by Thomas Moody, a blacksmith who purchased land near the present intersection of Poplar Avenue and Germantown Road.

The name Germantown was first used in 1836. There are three legends that lend some credence as to the naming of Germantown—the large population of German people, a railroad surveyor whose last name was German, and a German-born innkeeper named Mr. Luchen. Today, nobody knows which theory is correct. As more settlers began arriving, Col. G.P. Shepherd divided his prosperity into lots for the first subdivision in 1834.

Germantown Baptist Church organized as New Hope Baptist Church in 1836. The current chapel was built in 1870, making it the oldest church in the city. The Presbyterian Church organized in 1838; its sanctuary was constructed in 1851. The church survived the Civil War because the Union Army's Commanding Officer and Reverend Evans, the minister, were both Masons. The Methodist Church was founded in 1840 on McVay Road and moved to its current location in 1929.

Germantown incorporated in 1841. Stagecoaches came through on their route from Nashville, Tennessee, and Holly Springs, Mississippi, to Memphis. In 1850, Germantown had a population of over 250 citizens. The town began to experience an economic boom in 1852 with the coming of the Memphis and Charleston Railroad.

The Civil War crippled Germantown like it did to many places in the South. The town was occupied by Union troops during the war. In 1878, the town charter was temporarily lost during the yellow fever epidemic. During World War I, the anti-German sentiment forced Germantown to change its name to Nashoba for the duration of the war. In 1950, only 400 people lived within the city limits of Germantown. Germantown is a very friendly town that has kept a tight rein on preserving its culture and history. While moving forward with great progress, Germantown still retains its small town image and uniqueness of the past. By 1975, Germantown's population had swelled to 10,000 people.

This vignette with over 200 fascinating photographs will transport its readers on a historical journey spanning from 1825 to 1975. It will show how generations have molded and shaped the community of Germantown.

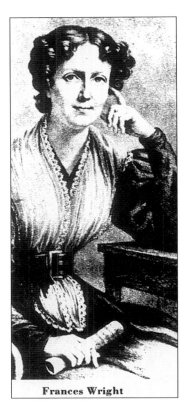

Frances Wright

Frances Wright first sought the advice of Andrew Jackson about land for her new concept, the training of slaves with a skill in order that they could be free. She arrived in Shelby County in October 1825 and inspected land along the Wolf River, near the sight where Germantown was later built. She then rode back to Nashville and bought eight slaves, five men and three women. When she returned to Shelby County she purchased 300 acres. Eventually, she bought more than 2,000 acres running northward from old Poplar Pike, including part of what is now Shelby Farms, bordered by the Wolf River. Wright named her new experimental settlement Nashoba, the Chickasaw name for "wolf." She was 30 years old, rich, and well-applauded in Europe and also in the United States. However, her idea was not popular among the Southern planters of the area. She was later looked down upon and despised by many that knew her. With a great many losses and a poorly managed plantation, Frances Wright's experiment began to wane. She soon abandoned her idea, but not before chartering a boat to Haiti and transporting her slaves to freedom. Her daughter, Frances Sylva d'Arusmont Guthrie, later sued for title to some of the land that her mother had lost; she was able to gain some of the property. Mrs. Guthrie lived on the property for several years before moving to Europe and her children later sold the old cabin and several hundred acres of land to their farm overseer, Thomas Payne. This ended Frances Wright's ownership of the large acreage.

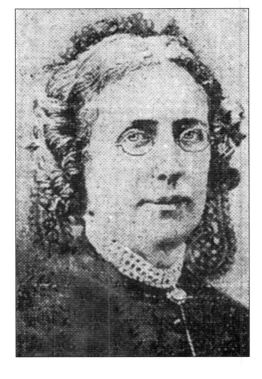

Frances Sylva d'Arusmont Guthrie, daughter of Frances Wright, owned and ran Nashoba Plantation for several years. Mr. Thomas Payne was her farm overseer. The people of Germantown contended that she was always formally dressed when she was in public. She had to sue to regain much of the property her mother had lost. Mrs. Guthrie later sold her property and moved to Europe.

One
NASHOBA

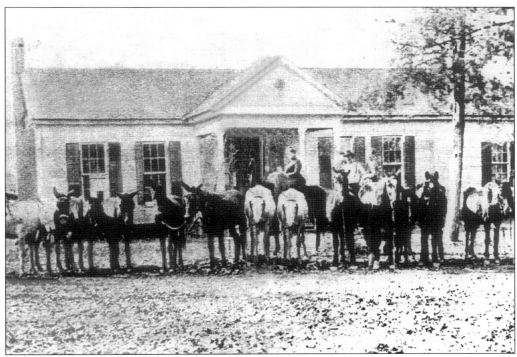

This is the only known photograph of the Nashoba Plantation house. In the 1890s, the original home was covered with clapboard. After Frances Wright's ownership, Thomas Payne, a farm manager for the Wright descendents, owned the property. The home remained on the property until about 1947 when L.B. Lary purchased the property, tore down the old house, and built his home on the same foundation; however he faced his new home to the east instead of south like the original home. This picture was probably taken between 1920 and 1925, when Mr. Payne owned the property. There was a long grove of cedar trees in front of the house that went all the way to Poplar Pike. The house sat about 400 to 500 feet from the road. At one time, the property was 2,000 acres, extending from the south side of Poplar Avenue and going north just beyond the Wolf River.

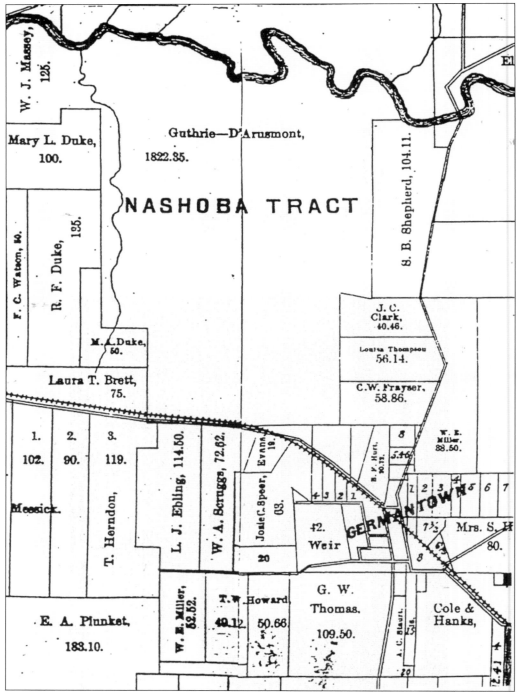

This is an early map of Neshoba Plantation. Miss Frances Wright from Scotland purchased this property along with eight slaves to begin an experimental colony. Her idea was to teach the slaves a skill and then emancipate them into society. The colony closed after just a few years; it was not a successful experiment.

Two
CHURCHES AND
PASTORS

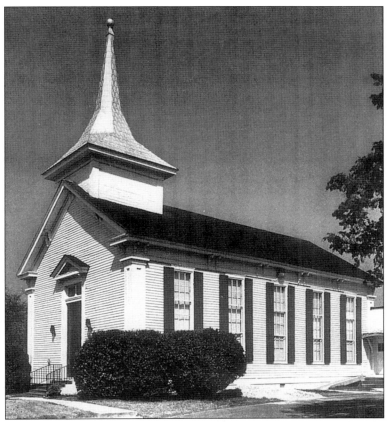

Organized in 1836 as New Hope Baptist Church, the Germantown Baptist Church is the oldest church in Germantown. In 1862, Union soldiers burned the original church. The present church on Germantown Road was built in 1870.

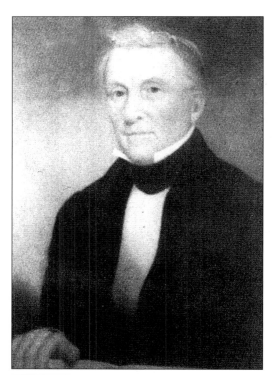

Elder Jeremiah Burns was pastor of the Germantown Baptist Church from 1854 to 1857. He gave the church a Bible that had been saved from the church fire during the Civil War. Burns assisted the church for many years after being the pastor.

St. George's Episcopal Church was situated west of the Presbyterian parsonage. In the early 1800s, the communicants met in a private home. The chapel was dedicated March 17, 1937. The original structure is now a chapel at St. George's current location on Poplar Avenue.

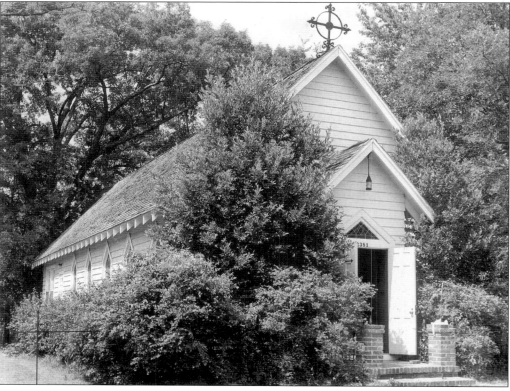

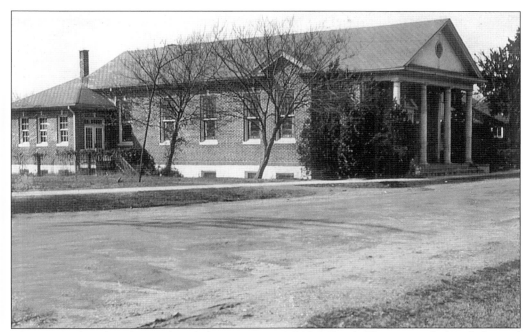

The Methodist church was founded in 1840 on McVay Road. The original church burned during the Civil War. A second church was struck by lightening and also burned. The current church was built on Germantown Road in 1929.

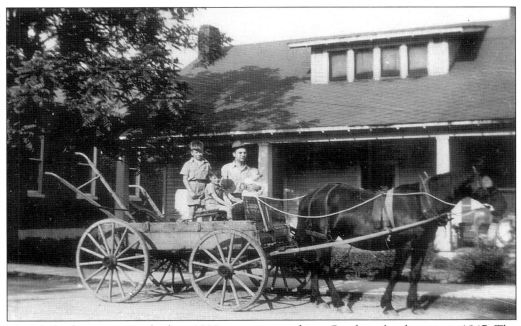

The Methodist parsonage, built in 1929, was converted into Sunday school rooms in 1947. The building was torn down in 1957.

Above left: Dr. Richard Riley Evans was born in Smith County, Tennessee. He graduated from Center College in Danville, Kentucky, and then earned his doctorate at Princeton University in 1849. Dr. Evans became the pastor of Germantown Presbyterian Church in 1850. In 1851, Germantown Presbyterian built their first permanent place of worship. This sanctuary is the oldest remaining public building in Germantown; it is still in use as the R.R. Evans chapel. Dr. Evans was a chaplain of Germantown Lodge #95. He served the church as pastor until 1903.

Above right: Rev. James A. Warren (1888–1974) was born in DeKalb, Mississippi. He attended Southwestern Presbyterian University and Divinity School at Clarksville, Tennessee, and was ordained by the North Alabama Presbytery 1917. Reverend Warren came to Germantown Presbyterian Church in 1931 and served as pastor until 1953 and again from 1957 to 1959. Dr. Warren later served as Pastor Emeritus for Germantown Presbyterian Church.

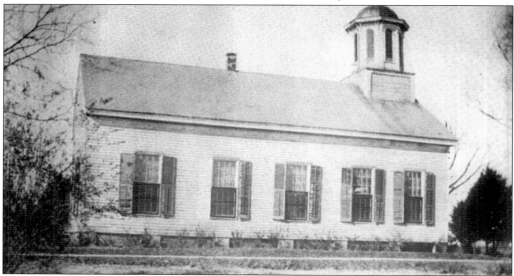

Organized in 1838, the Germantown Presbyterian Church built its sanctuary in 1851 and added a bell tower in 1867. The church survived the Civil War because the commanding officer of the Union Army and Reverend Evans, the minister, were both Masons. In 1959, the church building was reoriented from north/south to east/west.

14

Three
GERMANTOWN PEOPLE

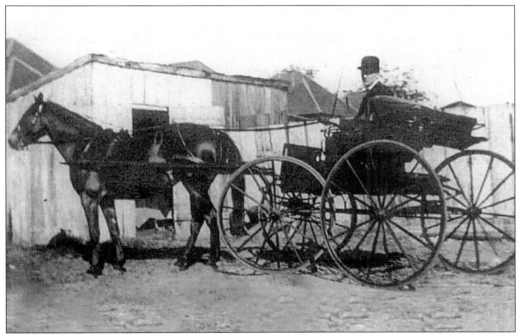

Albert G. Kimbrough (1854–1934) was a leading political figure in Shelby County. He was a graduate of the old Macon College in Macon, Tennessee. First elected to the Shelby County Court in 1888, Mr. Kimbrough served until his retirement in 1912. He was chairman for six terms and served his district as magistrate for 30 years. Kimbrough was also a trustee at Germantown Methodist Church for nearly 50 years. He was very active in the Masonic Lodge and served as State Commander in 1895. He is pictured at his family-owned plantation, Cotton Plant.

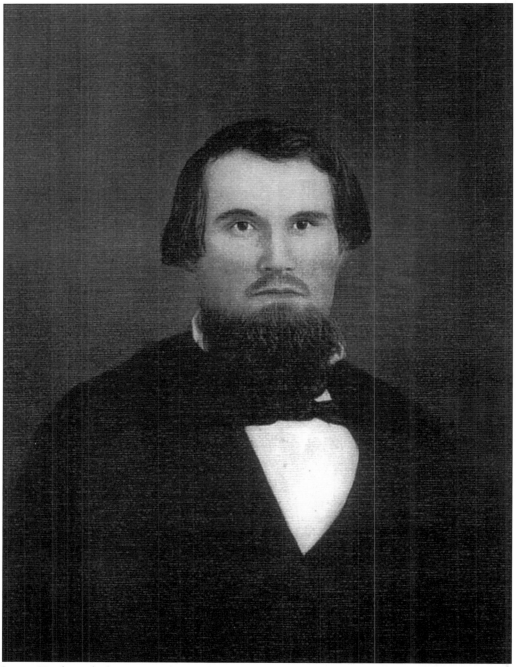

James Kimbrough (1814–1867) was the largest landowner in Germantown before the Civil War. His plantation Cotton Plant was comprised of 1,400 acres of rich cotton land. He was a very successful planter. Mr. Kimbrough and his son, Albert, were both members of Germantown Lodge #95.

Through her kindness to the Union soldiers, Mary Freeman Kimbrough, the wife of James Kimbrough, was able to save her beautiful home, Cotton Plant.

This early photograph of Joseph and Agnes Brooks was taken at the side of their plantation home, Woodlawn, located on Poplar Pike. The old home stood about 800 feet south of the Southern Railroad. The house has been restored and moved to another location on the same land owned by Joseph Brooks. His great grandson, Walter D. Wills III, still owns the old home.

Joseph Brooks Kirby was the son of John Anderson Kirby and Ann Eliza Brooks. His early education was acquired from Mount Moriah School on Winchester Road, the Memphis Military Academy, and Watson Business College. Kirby conducted the businesses of both the Brooks and Kirby families. He operated the large Mississippi and Arkansas ancestral cotton plantation of his grandfather Joseph Brooks. Kirby married Dorothy Gordon Walker in 1920. She was very active in the King's Daughter's, the Red Cross, and the Suburban Garden Club and was a supporting founder of St. George's Episcopal Church of Germantown. Joseph B. Kirby was a third generation member of Germantown Baptist Church. He was a member of the Civic Club and Memphis Country Club and was director of the Commercial and Industrial Bank. His children are Dorothy Gordon Kirby, now Mrs. Walter D. Wills Jr., and Louise Ann Kirby, now Mrs. William J. Ellis. The Kirby and Brookes families have been very active in Germantown history for several generations.

Joseph Brooks (1819–1897) was born in Greenville, North Carolina. He moved to the Germantown area with his parents, Wilks and Patsy Brooks, in 1834. In 1835, with his father's assistance, he constructed his beautiful home "Woodlawn." The 640-acre plantation was on the Cherokee Tract, now Poplar Pike in the Ridgway community. Over the years, Mr. Brooks added large tracts of land to the property. In 1847, Joseph married Agnes Nelson Dandridge in Bolivar, Tennessee. Mr. Brooks was quite a successful planter. He would ride horseback to New Orleans to sell his cotton. The Brooks family is one of the oldest families in the germantown area. Mrs. Walter D. (Dorothy Kirby) Wills Jr. is a descendant of the family. "Woodlawn" is on the National Register of Historic Places.

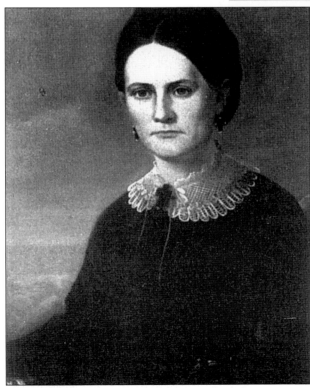

Agnes Nelson Dandridge Brooks (1828–1911) was the daughter of Robert and Ann Dandridge of Richmond, Virginia.

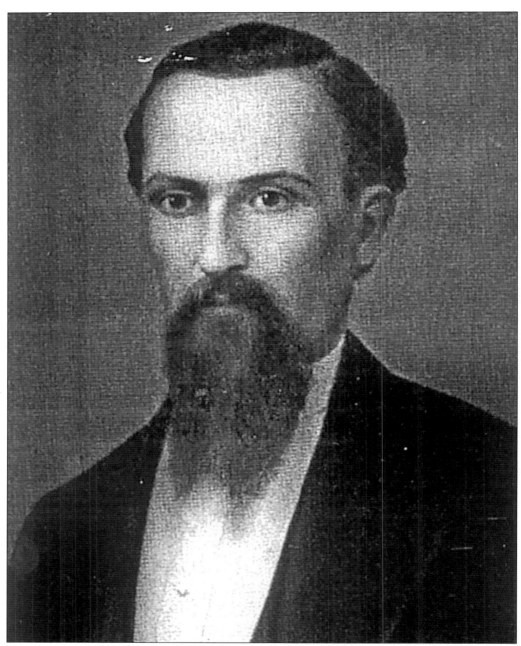

John Anderson Kirby (1842–1929) was one of the largest land owners in Shelby County. He acquired large tracts of land in many areas of the county. He purchased 2,000 acres of prime cotton land in Tunica, Mississippi, in 1877. In 1901, he purchased another large plantation in Mound City, Arkansas. Kirby Road is named in his honor. The Kirby Farm on Poplar Pike was the home of Mr. Kirby. John A. Kirby enlisted with the Shelby Greys in Company A, 4th Tennessee Infantry Regiment and was mustered in at Germantown on May 15, 1861. He was in engagements at Belmont, Shiloh, and Missionary Ridge. Kirby was captured in 1863 and imprisoned at Rock Island, Illinois.

In 1870, John A. Kirby married Ann Eliza Brooks, daughter of Joseph Brooks and Agnes Nelson Dandridge of Germantown. The old Kirby house, located on the old plank road where the Cherokee Indians traveled, is on the National Register for Historic Places and is listed in the Germantown Historical Commission. It was the first voting place and where the Justice of the Peace, Eppy White, performed marriages. Eppy White was the first owner of this property. Mr. White later sold the property and purchased a large plantation that became known as White Station. The Kirby house has been restored by Walter D. Wills III, great-grandson of John Anderson Kirby.

Arthur O'Neill, one of the earliest known blacksmiths of Germantown, was a soldier in Ireland before coming to the United States in 1853. Mr. O'Neill and son, Charles, ran a blacksmith shop on the corner of Germantown Road and North Street.

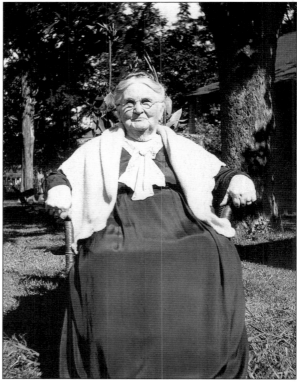

Mrs. Nannie O'Neill, wife of Arthur O'Neill, an early Germantown blacksmith, was a niece of William Twyford, Germantown's first settler. Mrs. O'Neill was also the mother of Miss Pearl O'Neill, a Germantown teacher for 53 years.

Dr. Thomas H. Williams (1849–1921), one of the early doctors in Germantown, was born in Winchester, Tennessee. Williams graduated from the Jefferson Medical College in 1872. He stood in the forefront of his class and three times declined to become to become a member of the faculty of his alma mater. He moved to Germantown in 1880 after practicing in Raleigh for seven years. He married Martha Myrick. Dr. Williams was one the oldest Masons in the county and was a member of the Germantown lodge. His medical advice was highly considered by all of his patients and he was well received by all who knew him. He is the grandfather of Mary Agnes Williams Prescott of Germantown.

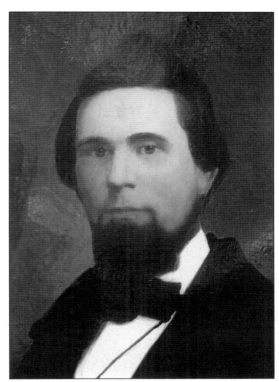

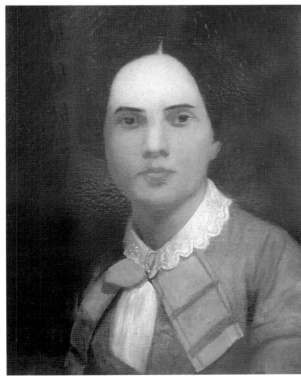

Martha Myrick Williams (1858–1929) was the wife of Dr. Thomas Harvey Williams.

Jack Barry was mayor of Germantown for 24 years. He held the position longer than any other mayor in Germantown. Barry moved to Germantown in 1924 as a cotton buyer. When Mayor Barry took office, there were approximately 200 people living in Germantown. He purchased the first fire engine owned by Germantown and was a member of the volunteer fire department. Mayor Barry was well respected by the citizens of Germantown.

Harvey S. Williams, well contractor, put in most of the early wells in Germantown and did well repair. His father, Dr. Thomas Harvey Williams, was an early doctor in Germantown. Mary Agnes Williams Prescott is his daughter.

In 1909, Miss Mabel C. Williams was one of seven women on the 20-member panel founded to persuade Normal School (now University of Memphis) to locate in Memphis. She was the first female president of the Tennessee Public Officers Association. Miss Williams was Shelby County's School Superintendent from 1909 to 1913. In the mid-1930s, she was the Tennessee State President of the Parent-Teacher's Association. Williams was very instrumental in getting the high school built in Germantown; it was named Mabel C. Williams High in her honor.

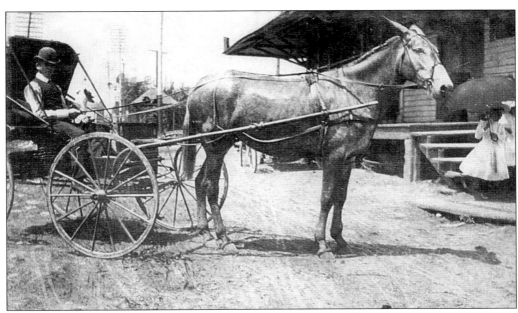

James Turner poses beside the old Germantown depot. Mr. Turner was a saloon owner in Germantown. At the time of this photo, Germantown had five saloons, c. 1912.

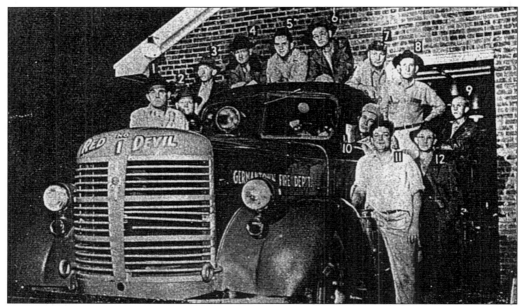

Volunteers staffed the Germantown Fire Department until 1963. This picture, taken in 1949, shows the first fire engine—Red Devil #1. The following are photographed from left to right: Joe Pickering, A.E. Frysen, Jack Barry, Minor Oakley, Bruce Law, E.L. Brooks, Guy Cantrell, O.J. Belk, J.E. Hodges, I.T. Miller, C.C. Burford, and M.H. Riggs.

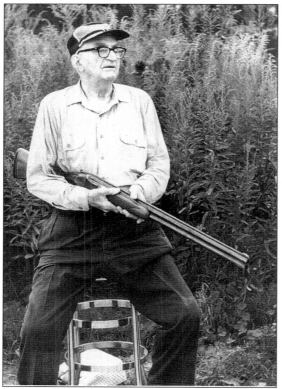

One of the largest farms in the late 1940s and 1950s belonged to Homer K. Jones. Mr. Jones was one of the first individuals to be licensed as a CPA in the state of Tennessee. He was quite successful, with branch offices in both Memphis and Washington, D.C. His large farm consisted of 640 acres of cotton and corn. Mr. Jones had 14 families that were his tenants. He also had a farm manager. Mr. Jones was an avid hunter and fisherman; he was known for his crack shot with both rifle and shotgun. He owned some of the best hunting dogs in the state and would breed his own quail and pheasant for hunting on his land. He later purchased additional property in Arkansas and Mississippi for the purpose of hunting and fishing. Homer K. Jones's original property consisted of what is known today as Southwind

Above left: The citizens of Germantown owe a great deal of gratitude to Harry Cloyes. Harry, a local historian born in Germantown, has been collecting the city's history for over 50 years. He is the owner of Oaklawn Garden on Poplar Pike. Harry has opened a public museum on his property with the historical memorabilia he has collected. His museum is very interesting and includes an early Southern Railroad caboose, Germantown's first fire engine, and the first jail. He has assisted many friends, neighbors, visitors, and school children with questions pertaining to the city. Thank you, Harry, for all that you do for the people of Germantown.

Above right: Johnny Piano, the first policeman in Germantown, was shown great respect by everyone who knew him. He was very popular with the students of Germantown High School and would assist whenever called upon.

Below right: Elizabeth Hancock was a third grade teacher at Germantown School.

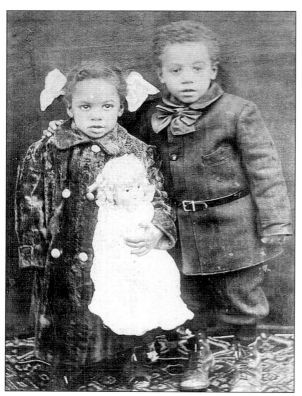

Julia Lane is pictured with her favorite doll and her brother, Robert Lane. The Lane family has been living in Germantown for over 100 years.

Mr. and Mrs. Pete Mitchell pose in front of their home that was located on the site of the current Kroger store at Poplar Avenue and Exeter Road.

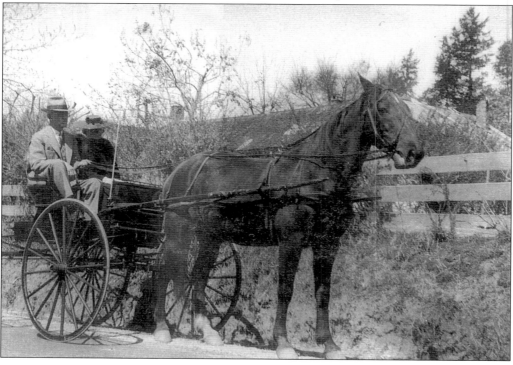

Dr. Richard W. Martin (1816–1877), born in Cabarrus County, North Carolina, was one of the first doctors in Germantown. He graduated from Davidson College in 1841 and received his medical degree in Philadelphia. Dr. Martin moved to Germantown in 1868 after living in Red Banks, Mississippi. His Germantown property was located on Dogwood Road. He was married three times and had 13 children.

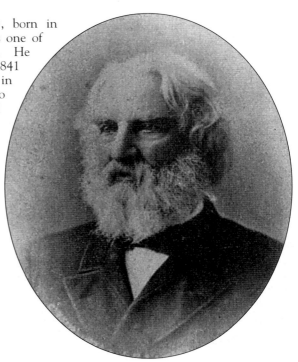

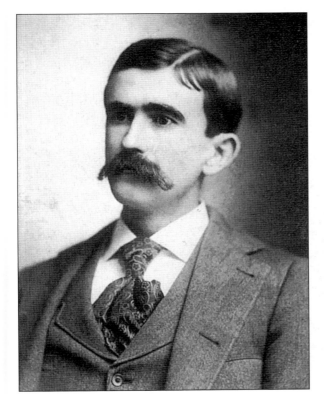

William Crawford Martin (1864–1946) was the son of Dr. R.W. Martin of Germantown. Dr. Martin was one of Germantown's first doctors, settling here in 1868. W.C. Martin was a farmer along old Poplar Pike near the area where Burnam Woods Subdivision is now located. He was a member of the first class to graduate from Davidson College in Davidson, North Carolina. Many descendants of the Martin family remain in Germantown.

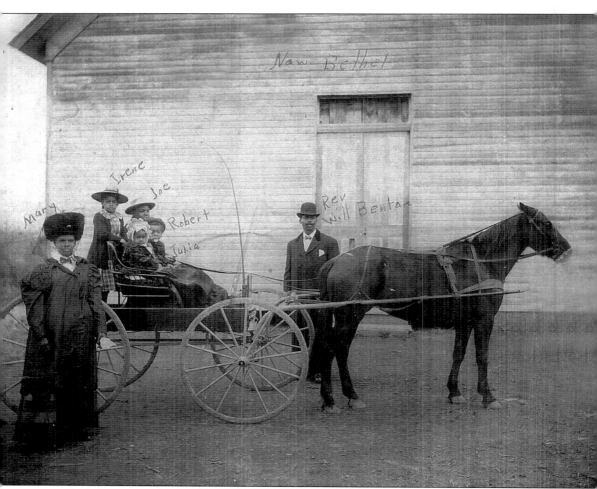

Mary Lane, the mother of Irene, Joe, Robert, and Julia, poses with Rev. Will Benton of New Bethel Baptist Church in Germantown.

Four

SCHOOL DAYS

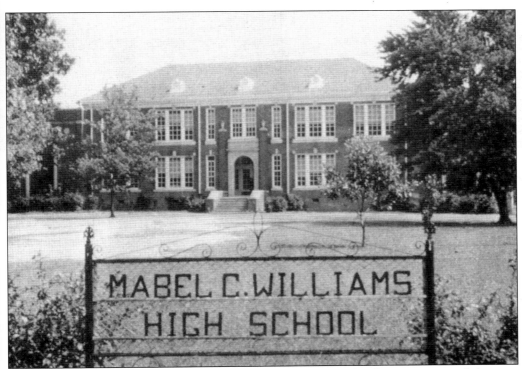

In 1889, W.M. Batts sold this property to Germantown High School Association and the next year a small frame building of four rooms was erected. Miss Mabel C. Williams was appointed principal. In 1911, a new school was built and named M.C. Williams High School in her honor. The old building was torn down in 1973.

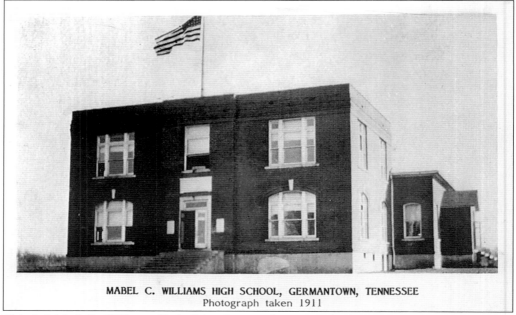

MABEL C. WILLIAMS HIGH SCHOOL, GERMANTOWN, TENNESSEE
Photograph taken 1911

This is Mabel C. Williams High School soon after it was built in 1911. One of the oldest schools in Shelby County, the school was improved over the years by many different additions. It has always been recognized as an outstanding educational institution.

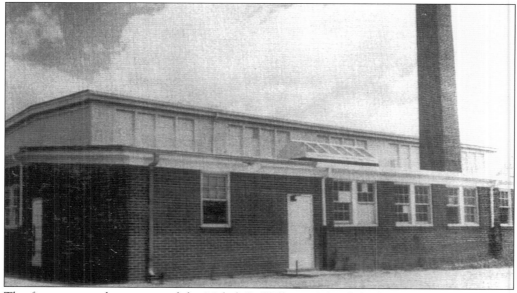

The first gym on the campus of the Mabel C. Williams School, built in 1927, was originally heated by two coal-burning stoves. It was torn down in 1973.

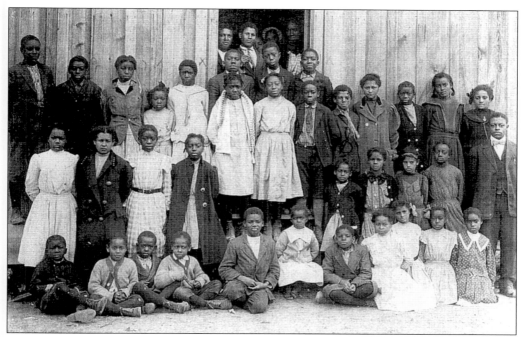

This is an early photograph of students in front of Nashoba School, a little wooden school house located on the north side of the Southern Railroad in Germantown. Land was given by the Thompson family for the construction of the school.

Germantown High School's class of 1923 had 16 graduates, eight boys and eight girls.

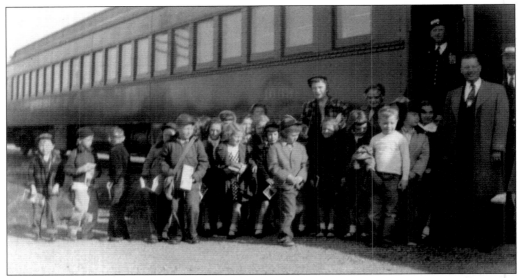

Students from Ms. Elizabeth Hancock's third grade class are pictured by a train in 1959. Ms. Hancock would take her students to many special events in order to broaden their education.

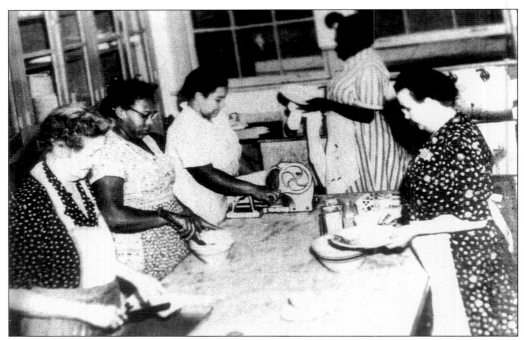

Mrs. Jones (right) and Mrs. Owens (left) are pictured with the workers in the old cafeteria on the north side of the old gym.

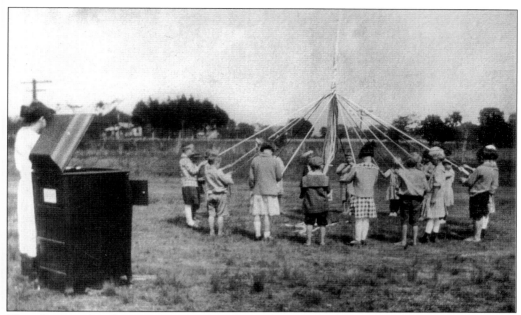

This photograph, taken in 1920, shows young students around the Maypole in front of Mabel C. Williams High School. This was a traditional event during the school year. Notice the old phonograph player.

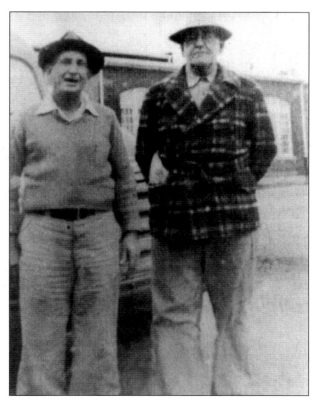

Two Germantown School bus drivers, Mr. Belk and Mr. Hancock, are pictured in 1953.

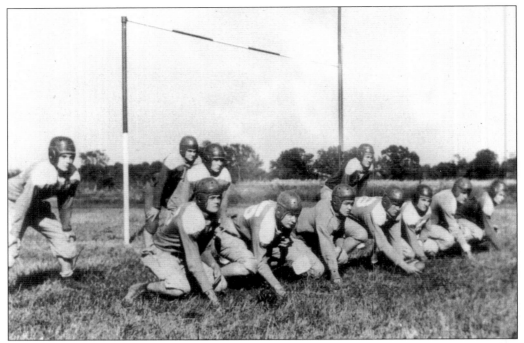

The 1939 Germantown High School football team is pictured here. Germantown has always had skilled coaches and talented players. They have had very good success with their sports programs.

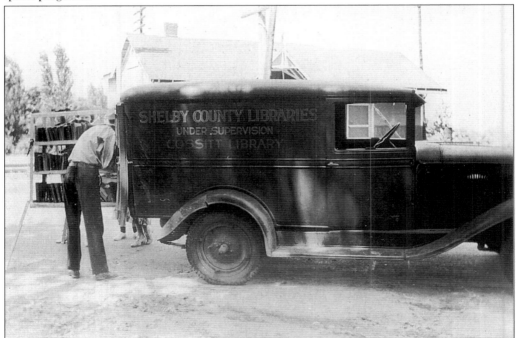

This is a 1927 Shelby County Library truck. Before schools had their own libraries, this truck would travel to the schools and the students would choose their favorite selections.

Elizabeth Hancock, Nannie Mae Holden, and Mrs. Pearl O'Neill Scruggs, all Germantown teachers, are pictured left to right in 1959.

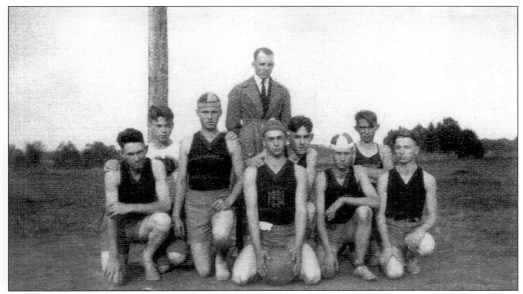

Germantown High School coach C.C. Burford is pictured with his talented basketball team.

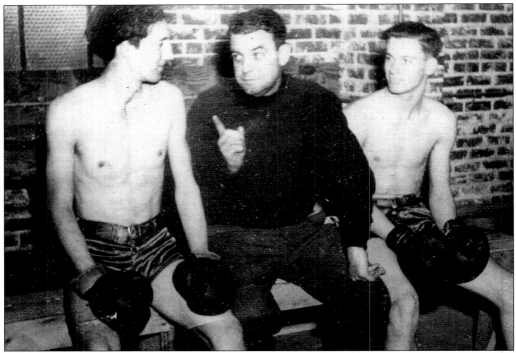

C.C. Burford was the basketball, football, and boxing coach at the high school in 1940.

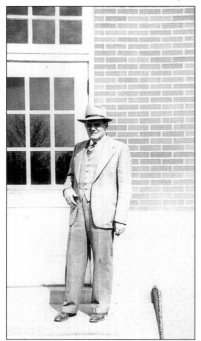

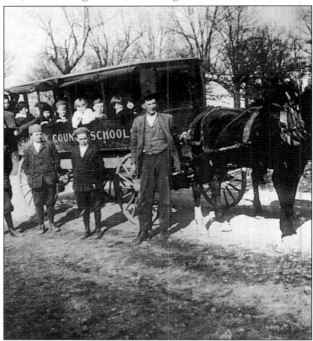

Above left: Ralph Hunt, the principal of Mabel C. Williams High School, is pictured in 1945.
Above right: A wagonette and driver, G.B. Howard, are pictured with students in 1918; from left to right are Ferrell Johnson, Sidney Johnson, and Dorothy Skinner.

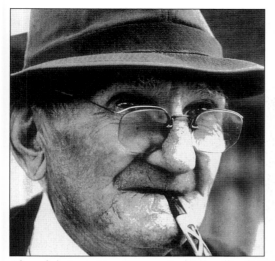
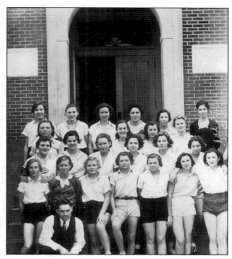

Above left: Jesse Van "Happy Jack" Sandlin (1899–1981) was born in a log cabin in the hills of Mt. Pleasant, Mississippi. As a young man, Jesse discovered he had a talent for singing and making people laugh. Jesse left home at a young age and made his way to Chicago, Illinois, to find employment. He found work in a south side speakeasy club in the Cicero area. "Happy Jack" performed Vaudeville shows, sang, and danced from the mid-1920s until 1935. His dance routine was known as the "hucklebuck." In 1939, he moved to Germantown and married a local girl, Dorothy Lee Robertson. His nickname, "Happy Jack," was his title billing in Chicago and later became the name that people in Germantown called him. Many friends and school children would see him on the street and call out, "Hey, Happy Jack, do the hucklebuck for me!" He would smile and put on a show. "Happy Jack" was a unique and cheerful person; he kept old and young alike smiling with his singing and dancing. For many years, Jesse Van Sandlin was a regular around town, running errands, panhandling, and dancing the hucklebuck on the street corners. He always wore his old gray hat and smoked his favorite pipe, but most of all he displayed his best known trademark, his happy face.

Above right: The 1935 Germantown High School girls' basketball team is pictured here.

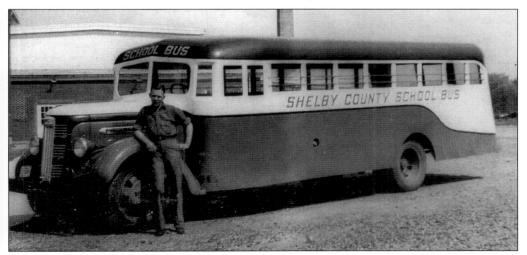

This picture shows an early Shelby County school bus designed with a red top, white center, and blue bottom, *c.* 1930.

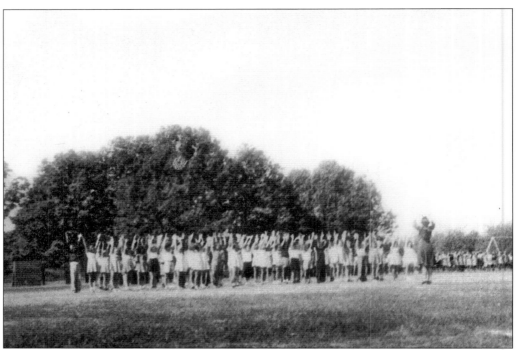

Elizabeth Hancock's third grade class plays on the playground at Germantown school in 1958.

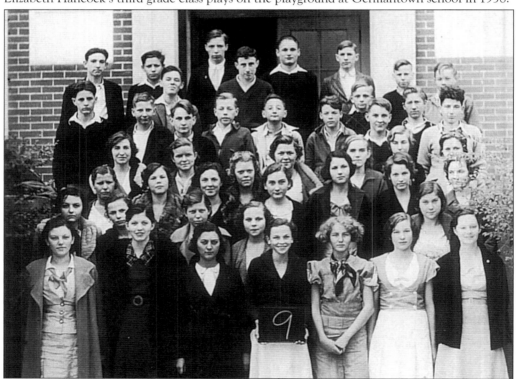

The class of 1933 is pictured in the ninth grade class at Germantown Junior High School.

Five

STORES AND PLACES

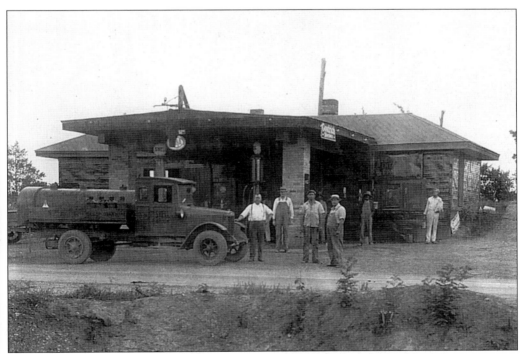

Clint Howard Garage Service Station on Poplar Pike was one of the oldest service stations in Germantown. The old station was located near the corner where Eastern and Poplar Pike merge.

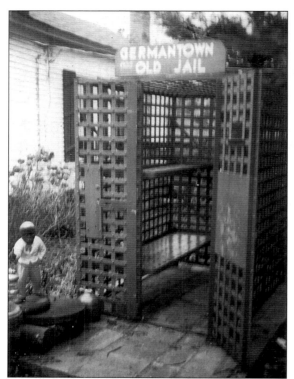

The first jail in Germantown was located in as tin building under the water tower. The town marshal would arrest a prisoner, lock him in a jail cell, and call the sheriff to take him to the county jail. This old jail was used until 1967.

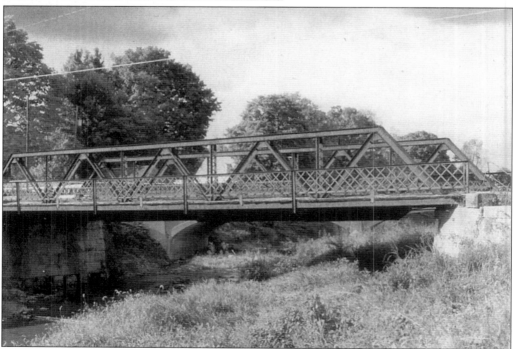

Wolf River Bridge on Germantown Road was made of steel and was just wide enough for a wagon or a Model T automobile to pass by each other.

This 1910 ad shows land for sale in Germantown. Notice the prices.

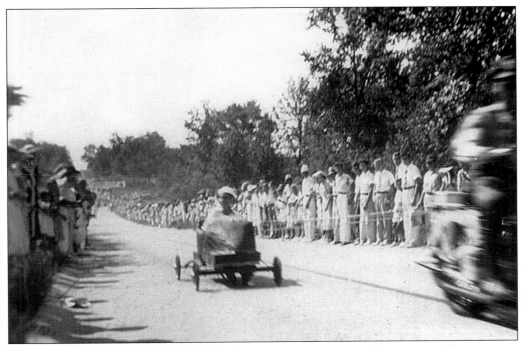

In the late 1930s, the Soap Box Derby Races was an annual event in Germantown. When Poplar Avenue was two lanes the race was held on the steep hill east of St. George's Church, c. 1937.

This photograph shows many things including how open Germantown was in the early days, the Presbyterian Church and old Presbyterian Manse, and an early farm and log cabin, *c.* 1920.

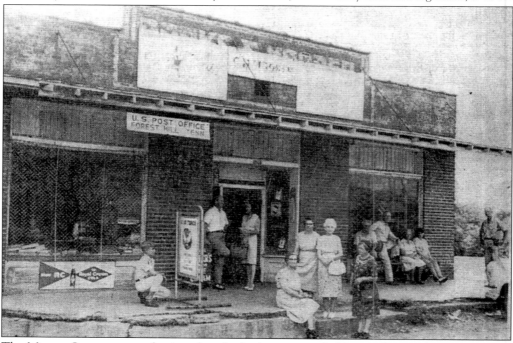

The Moorer Store was a gathering place for both young and older residents. The following are pictured from left to right: Tim Hoke (looking at the Air Force sign), Jamie Maddox, Mrs. Asa H. Hoke (standing in the door), Mrs. Moorer (seated in front), Mrs. F.M. Downs, Mrs. J.E. Clark, Mrs. Tom Wright (seated on bench), H.M. Jackson, A.H. Smith, Mrs. A.H. Smith, Mrs. Ray Smith, and Ray Neal (standing).

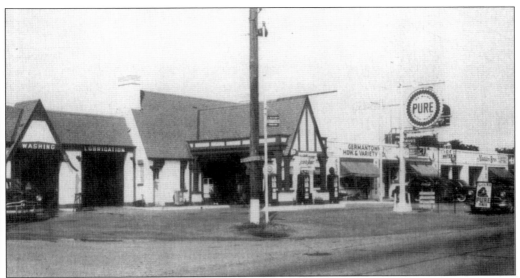

In the early 1940s, Germantown had a shopping center referred to by locals as "The Corner." The following businesses are seen: Pure Oil station, restaurant, McHenry's Hardware, Jack Hix Pool Hall, Walker Machine Shop, Maddox Brothers Cleaners, and Cantrell Grocery.

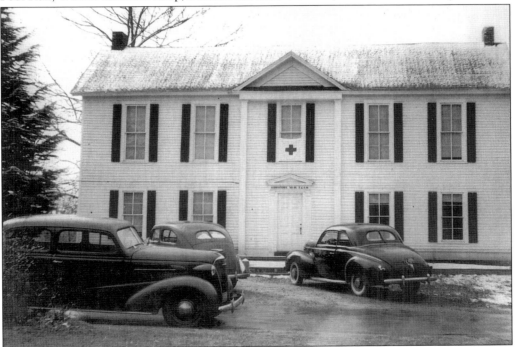

Masonic Lodge #95 was organized on April 7, 1841, with Joseph Cotton as Worshipful Master. During the Civil War, when Federal forces occupied Germantown, the lodge, as well as the Presbyterian church, were spared when Reverend Evans, a Mason, interceded with the commanding officer, also a Mason. The first public school in Germantown was located in the lodge. It also served as a Civil War hospital and Red Cross office in WWII. The building was torn down in 1985.

The original City Hall of Germantown is seen in 1945.

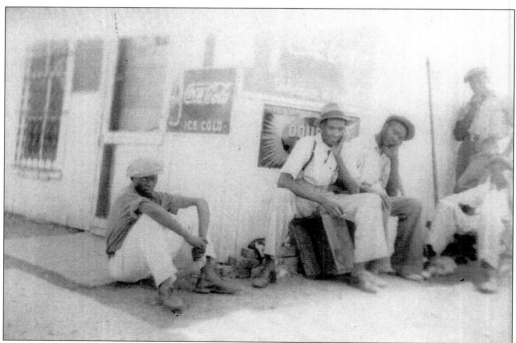

Farm hands wait in front of the A.B. Lanning Store in the summer of 1940.

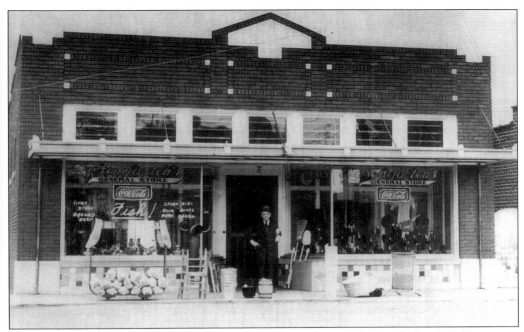

In 1928, Louis Rosengarten built this red brick mercantile store. Mr. and Mrs. A.E. Frysen ran the store from 1942 to 1969. The store was later connected to Stanley and Mary Law's store and became a restaurant.

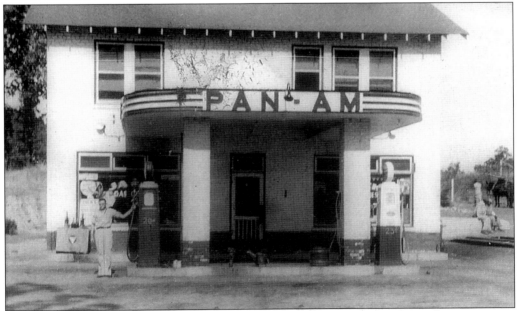

The Pan Am Service Station stood on the northwest corner of Poplar and Germantown Roads, where the Exxon is located today. James Burd ran the station for many years; people referred to it as Jaybird's Station. Later, the Hopper family ran it and it was known as Hopper's Grocery. The Hooper family moved their grocery business three times; this was their second location in Germantown. This photo was taken in 1938.

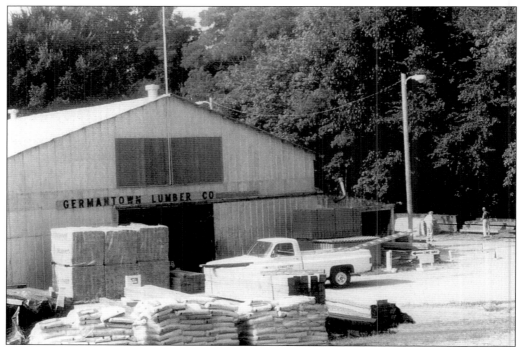

The Germantown Lumber Yard on Poplar Pike was first owned by George Robert King. Mr. King had a large hog lot at this same location before opening his lumber yard. Boyd Arthur Sr. built the current lumber yard in 1945. It had several owners before being bought by the current owners, Charles and Jason Speed, in 1990. Germantown's first lumber business was a sawmill owned by R.E. Crosby on West Street. C.M. Callis also owned an early lumber yard.

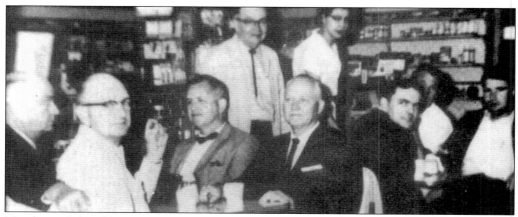

Members of the old Germantown Business Association, which later became the Chamber of Commerce, met at Posey's Drug Store for many years during the 1950s for a cup of coffee and conversation. Posey's Drug Store was located where the First Tennessee Bank is today, on the corner of Poplar Avenue and Germantown Road.

Germantown's post office shared a building with the Memphis Light, Gas & Water Division at the corner of Germantown and Hot Tamale Roads, now Dogwood Road.

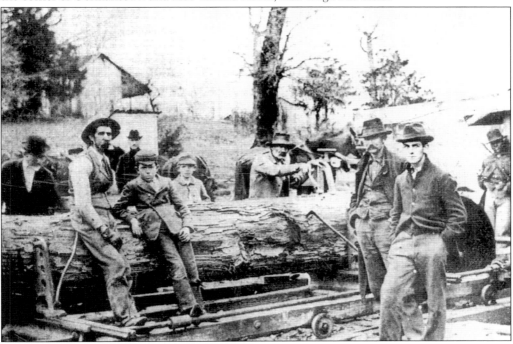

One of the earliest sawmills in Germantown was the R.E. Crosby Sawmill Company. This photograph shows several employees posing for the photographer. The old mill, located along West Street, was said to be near the present-day Germantown Lumber Company, c. 1890.

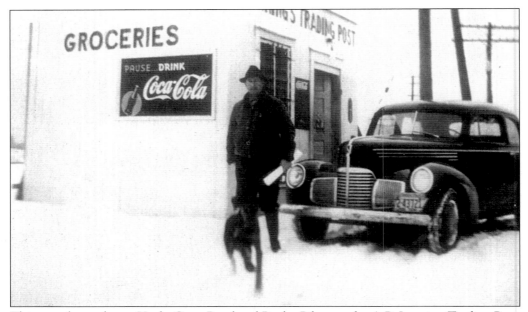

This store located near Hacks Cross Road and Poplar Pike was the A.P. Lanning Trading Post. Mr. Lanning traded old guns and swords and sold groceries and gas, c. 1942.

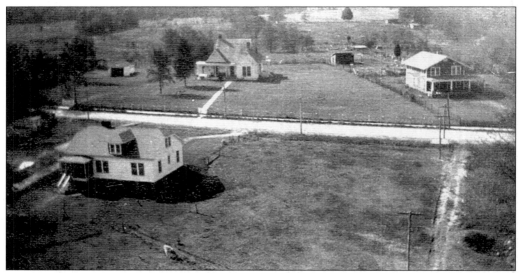

This early photograph showing Mrs. Mamie Thomas's home (center) on Poplar Pike shows how open the land was in early Germantown.

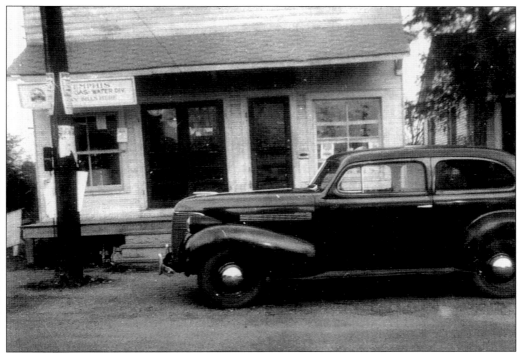

In 1926, the second post office and the original Memphis Light, Gas & Water office were constructed on the southeast corner of Germantown and Dogwood Roads.

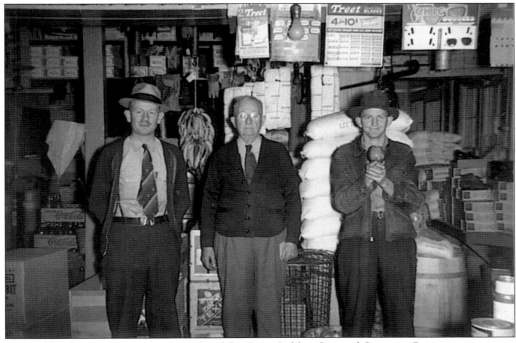

Mr. Oakley (center) is pictured inside of the S.A. Oakley General Store in Germantown.

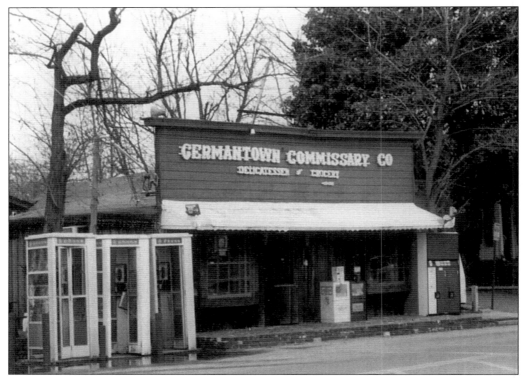

Germantown Commissary, a good place to eat, is located in the center of town on Germantown Road. This was the original site of Dr. John G. Seay's office.

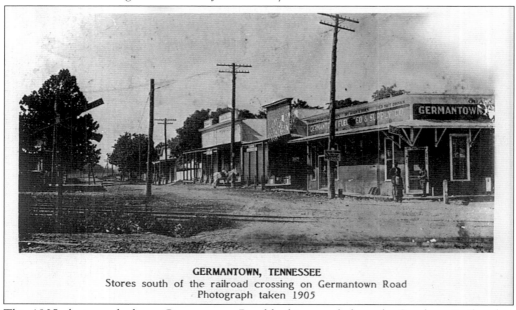

GERMANTOWN, TENNESSEE
Stores south of the railroad crossing on Germantown Road
Photograph taken 1905

This 1905 photograph shows Germantown Road looking south from the Southern Railroad to Poplar Pike. From the corner looking south the buildings are Furr Grocery Store, C.R. King store, and C.M. Callis store; on the left is the home of Dr. John G. Seay.

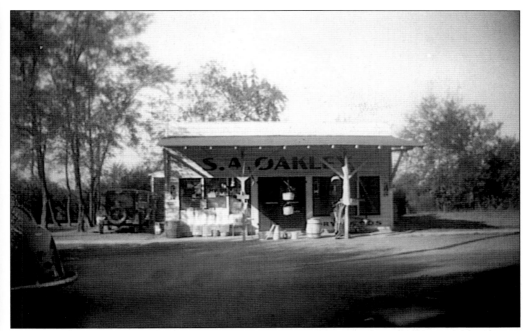

S.A. Oakley established his mercantile and grocery store in 1938. Mr. Oakley sold hardware, canned goods, feed, kerosene, and candy. His son, Minor Oakley, ran the store until 1952.

Louis Tillman, owner of an early grocery store that was located where the Three Oaks Grill is today, had one of the earliest places to buy gas, c. 1927.

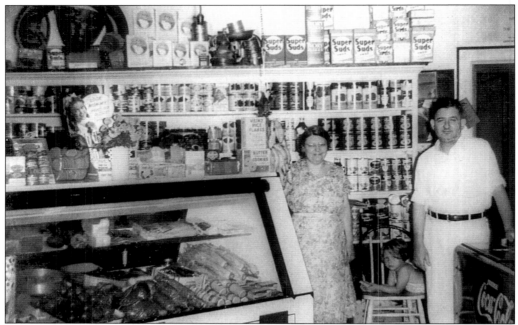

Mr. and Mrs. Stanley Law proudly pose in their store in old Germantown. The Laws were the parents of Bruce Law, mayor of Germantown. The store was located across the street from the Germantown Commissary.

Lunati's Grocery Store was built in 1918 on Germantown Road when it was a tree-shaded gravel road considered to be way out in the country. The Lunati family ran it for many years and later leased it to the Eason Hopper family who operated it as Hopper's Grocery. The Hoppers had previously operated a store on Poplar Avenue. Both the Lunatis and the Hoppers were loved by their customers and had a lucrative business. The building was torn down to widen Germantown Road.

Venn A. Furr owned an old store from 1895 to 1910 on the corner of Germantown and Poplar Pike in front of the Germantown Depot. Mr. Furr also owned a cotton farm in the Wolf River bottoms. He later bought a plantation in the Mississippi Delta.

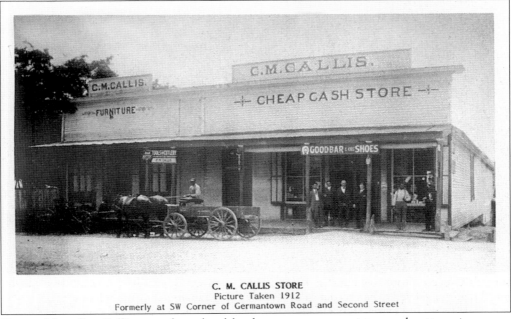

C. M. CALLIS STORE
Picture Taken 1912
Formerly at SW Corner of Germantown Road and Second Street

Cassius Marcellus Callis was a large local landowner, store proprietor, and cotton gin owner. This photo shows the old store, at one time the largest store in town, located on Germantown Road where the Methodist church is today. The first post office was in this store.

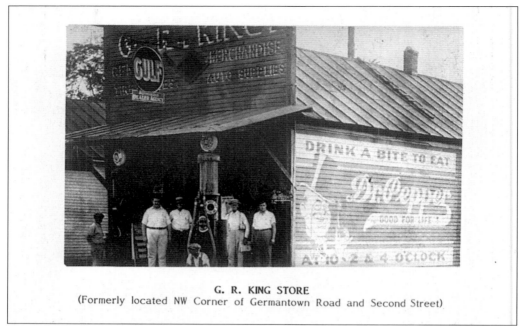

G. R. KING STORE
(Formerly located NW Corner of Germantown Road and Second Street)

George Robert King owned a store located on the northwest corner of Germantown Road and Second Street. Mr. King sold general merchandise, groceries, auto supplies, and gas. The store was torn down in the 1920s to make room for the construction of Rosengarten's Store.

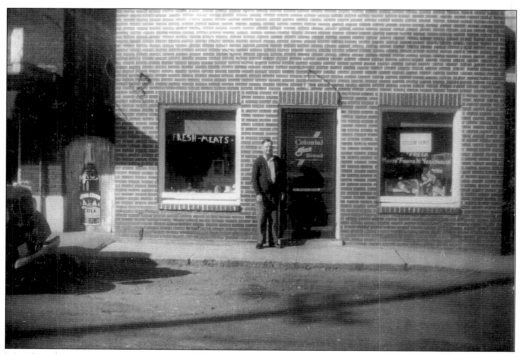

Mr. Stanley Law poses in front of his store located on the southwest corner of Germantown Road and Old Poplar Pike, 1939.

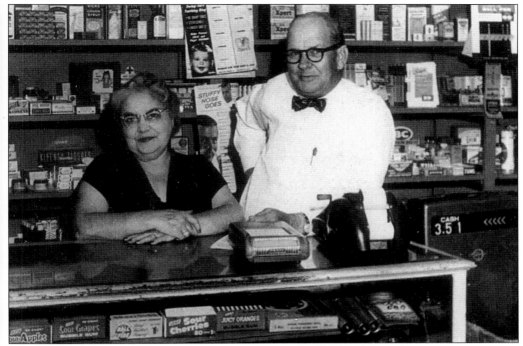

Notice all the products on the shelves of Mr. and Mrs. Frysen's store. Their store was on Germantown Road, in the center of town. The Frysens always went out of their way to assist their customers.

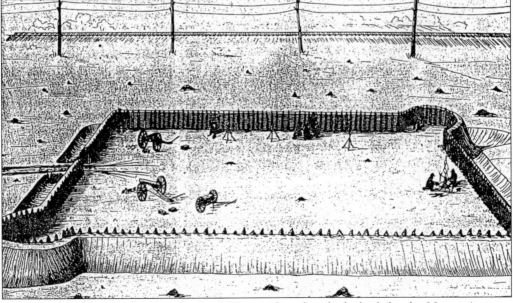

Fort Germantown was the site of a Civil War earthwork redoubt built by the Union Army as part of a series of forts guarding the Memphis Charleston Railroad. The fort was built in June 1863 by the 49th Illinois Infantry Regiment and was used until they were replaced by the 52nd Illinois in August 1863. The fort was abandoned and burned by the end of October 1863.

1876

GERMANTOWN.

This flourishing village has about 700 in-
..bitants and is located on the Memphis
..d Charleston R. R., in the southeastern
..rt of Shelby county, 15 miles from Mem-
..is, 16 from LaFayette, and 250 by rail
..m Nashville. It has a flouring mill, gin
..anufactory, three churches, Methodist,
..esbyterian and Baptist, and male and fe-
..ale schools. The various mercantile
..anches are fully represented, and the place
..teadily increasing in wealth and popula-
..n. The surrounding country is chiefly
..voted to cotton growing, and this staple
..ms the principal export. The Southern
..xpress and Western Union Telegraph Co's.
..ve offices here. Mail daily. Wm. E,
..ller, postmaster.

Business Directory.

..len, Frank, blacksmith.
..rk, J. A. C. & Bro., wagonmakers.
..le, E. M. carpenter.
..ans, Rev. R. R., (Presbyterian).
..zgerald, E. O., school teacher.
..rman, E., W., grocer.
..rt, B. F. & Sons, Gin Mnfrs.
..nson, A., hotel proprietor.
..nson, Rev. A., (Presbyterian).
..Kay, R. H., physician.
..rtin, R. W., physician.
..ller, Wm. E., Druggist.
..eil, A. & Son, blacksmiths.
..llips, J. P. & Bros., general store.
..aud, Miss S. E., school teacher.
..des, L. A., hotel proprietor.
..hman, L., physician.
..ruggs, R. W., General Store.
..ppard & Walker, general store.
..mpson, J. A., physician.
..lis, K. M., grocer.
..ght, A. J., grocer.

1887

GERMANTOWN.

Shelby County—M. & O. R. R.

A prosperous village of 400 inhabitants,
located in the midst of a cotton growing
district, 15 miles from Memphis, 295 from
Chattanooga, and 246 from Nashville via
Jackson and Grand Junction, or 247 via
Memphis. Exp., Southern. Tel., W. U.
Mail, daily. Miss Fanny Burnley, post-
master.

Alexander Mrs E B, teacher.
Allen Frank, blacksmith.
Anderson Rev J D (Baptist).
Anderson R T, justice of peace.
Brett James, justice of peace.
Bridges Mrs, hotel.
Bryant Rev W O (Baptist).
Burnley Miss Fannie, general store.
Callis C M, General Store and Cotton Gin.
Evans Rev R R (Presbyterian).
Gorman E W, saloon and livery.
Hatcher & King, general store and cotton.
Jones Rev H T (Methodist).
Lane S T, teacher.
McKay Mrs, hotel.
Malone Mrs, general store.
Miller W E & Son, gen store and drugs.
O'Nell H, blacksmith.
Parrott Rev A G (Baptist).
Patterson Joseph, saloon.
Richmond L, physician.
Shepherd E W, blacksmith.
Strickland G K, justice of peace.
Thomas Miss Annie L, music teacher.
Thomas G W & Co, gen store and cotton.
Thompson L B, gen store and druggist.
Tuggle & Kimbrough, flour mill.
Ulander N J, tel, exp and railroad agent.
Williams Dr, physician.
Yancy Edward, physician.

1890

GERMANTOWN.

Shelby County—M. & O. R. R.

A village of 375 inhabitants, locate..
miles from Memphis, 295 from Ch..
noogs, and 375 from Nashville. E..
Southern. Tel., W. U. Mail, da..
R. T. Anderson, postmaster.

Amaker Rev J H (Baptist).
Anderson R T, Justice and Not..
Blackwell Rev R Y (Methodist).
Bradley Bros, general store and cotton..
Callis C M, general store and cotton gi..
Cole J A, carpenter and builder.
Crosby R R & Co. saw mill.
Evans Rev R R (Presbyterian).
Fitzwater J M, blacksmith.
Garner J C, plasterer and mason.
Gorman E W, saloon, livery and gen..
store.
Hazlewood A S, railroad, exp and tel..
Jones Rev H T (Methodist).
Kimbrough A Y, justice of peace.
Krinbrough & Bradley, grist mill and..
ton gin.
McDonald W F, saloon.
McKay Mrs, hotel.
Martin W C & Co, general store.
Miller W E & Son, general store.
O'Nell A, blacksmith.
O'Nell H, blacksmith.
Parrott Rev A G (Baptist).
Patterson Joseph, saloon.
Richmond L, physician.
Strickland G K, justice of peace.
Taylor F W, shoemaker.
Thomas G W & Co, general store and co..
gin.
Williams Thomas H, physician.
Wright A J, saloon.
Yancy Edward, physician.

These early listings are printed from the 1876, 1887, and 1890 *Tennessee State Gazetteer*; they show the many different types of businesses and professions that were located in Germantown.

Six

GERMANTOWN DEPOT

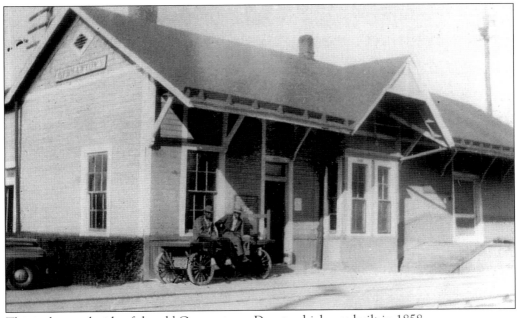

This is the north side of the old Germantown Depot, which was built in 1858.

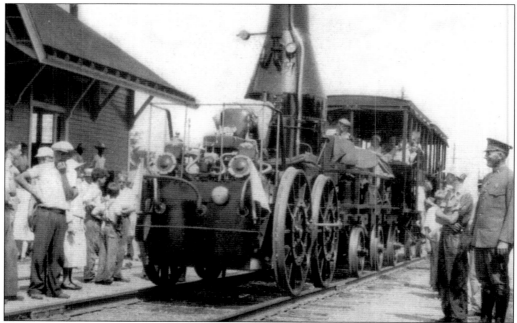

In 1852, the Memphis-Charleston Railroad was constructed through Germantown. The original depot was built in 1858 and was the community gathering place for Germantown. In 1948, the old depot burned and was rebuilt the same year. This photograph taken July 10, 1929, presents a replica of the first Memphis-Charleston Railroad train being met by the mayor and citizens.

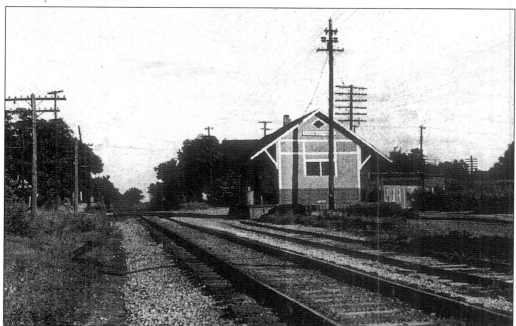

This is the north side, which faced the Southern Railroad, of the old Germantown Depot as it looked in 1935.

This is a photo of the
Germantown Depot during
the winter of 1945.

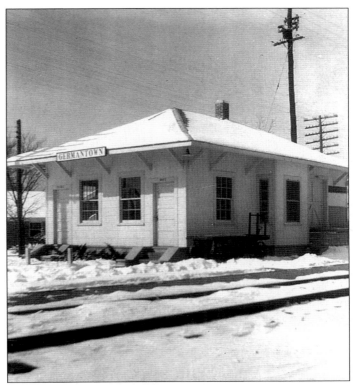

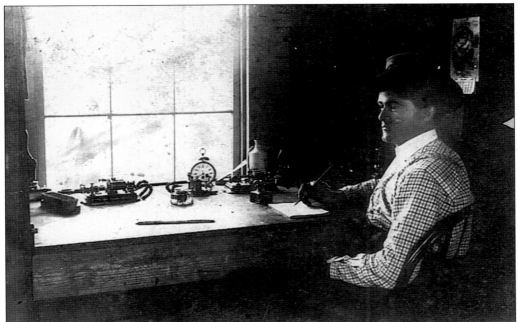

Luby Washington Robertson was the telegraph operator at the Germantown Railroad depot for
many years. This 1917 photograph shows the telegraph key and desk from where he sent
messages for the railroad and Germantown citizens.

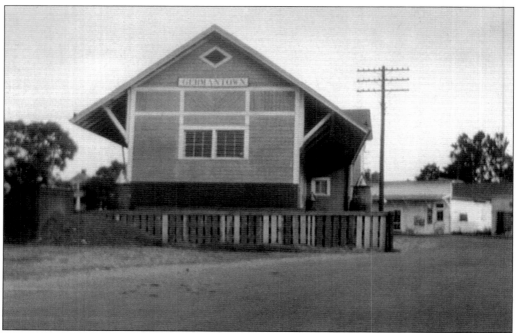

The Germantown Depot was the center of early town life. It was built high off the ground to allow a wagon to back up to the loading dock and load or unload cargo.

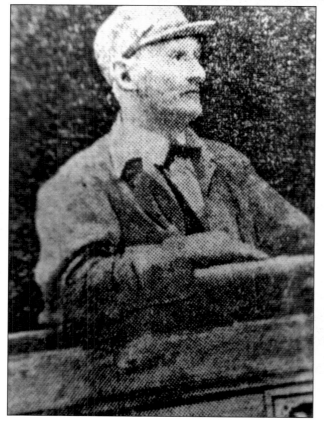

Mike Brady, one the Southern Railroad's best known engineers, was known by almost all of his passengers in Germantown. For over 50 years he ran an engine on the Southern Railroad, 40 of those years were on the Somerville Accommodation out of Memphis. He was known to hundreds of railroad men on many different routes and thousands of children to whom he would blow his whistle and wave as he passed by. He was truly loved by all of his friends and passengers.

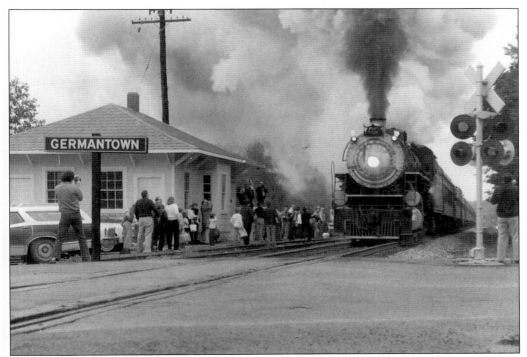

People line the tracks near the Germantown Depot to board a special train to Iuka, Mississippi. The ride aboard the steam engine required the passengers to wear goggles to keep cinders out of their eyes since the train windows were open.

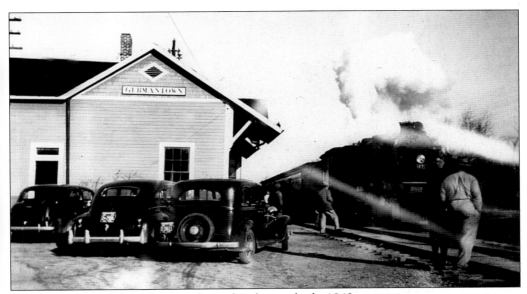

This is the original depot before it burned and was rebuilt, 1940.

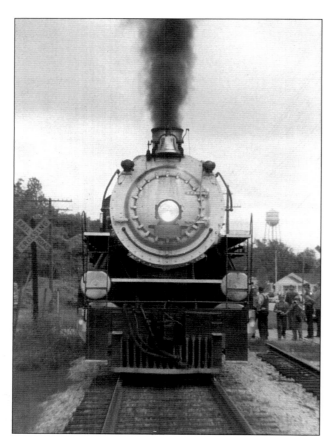

The old steam powered locomotive returns from a special train excursion to Iuka, Mississippi. It must head back to Memphis.

This early train engine was used by the Southern Railroad from 1900 until 1940.

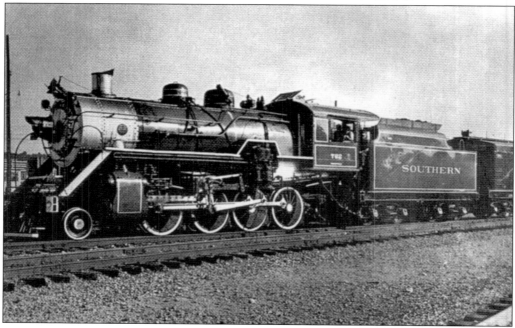

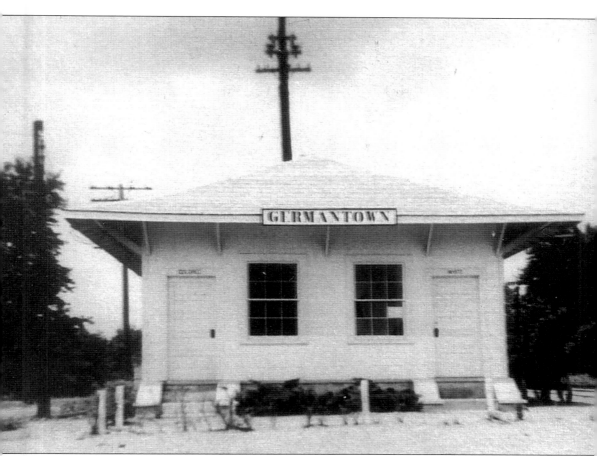

The Germantown Depot, constructed in 1858, served as a passenger station between Memphis and Williston, Tennessee. The depot was also a shipping center and a floral distribution point. The depot burned in 1948, but was rebuilt and restored to its original condition.

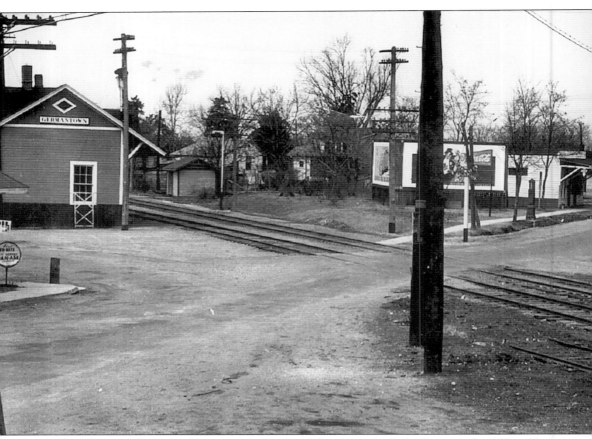

This photograph shows Germantown Road and the east side of the depot in the 1930s. Notice the old billboard in the background. This was the original depot that was built in 1858 and stood until it burned in 1948. The second depot was built in 1948 using some the old timbers from the original depot.

Seven
HORSES

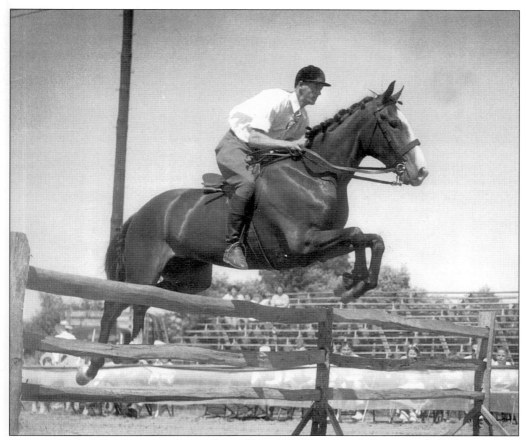

During the first Germantown horse show, Bant Mueller, one of the original doubters of the show, displays his skills in the jumping class. Bant was a master horseman and fox hunter.

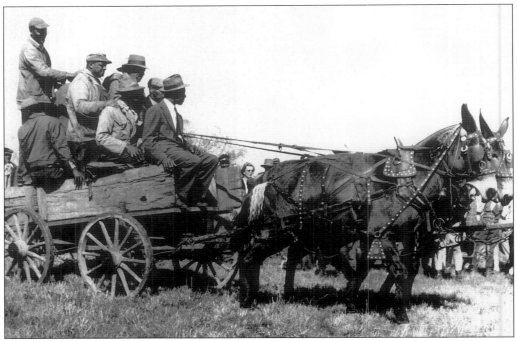

A mule and wagon race between the groomsmen at the show grounds took place at the midway point of the horse show. The race was enjoyed by participants and spectators, 1948.

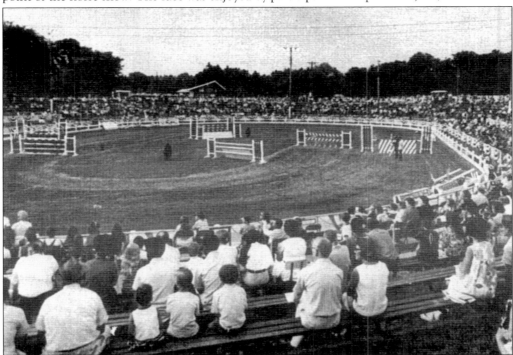

This photograph was taken during the hunter-jumper class division of the Germantown Charity Horse Show ring in 1975.

Here, at the Germantown Horse Show grounds, a groom gives special care and attention to a loyal friend. Many grooms also assisted in the training of horses, 1950.

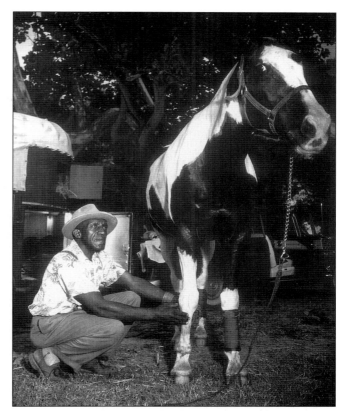

Mr. and Mrs. Bart Mueller show class as they soar over their jump at the Germantown Horse Show. Both Bart and Mary were early members of the Oak Grove Hunt Club.

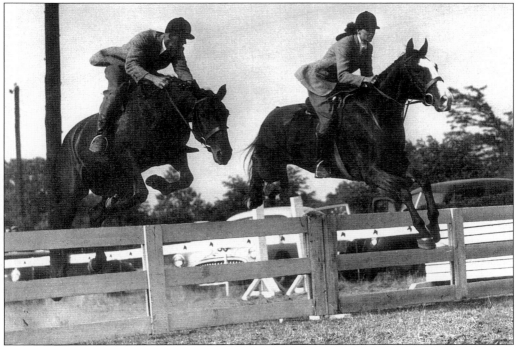

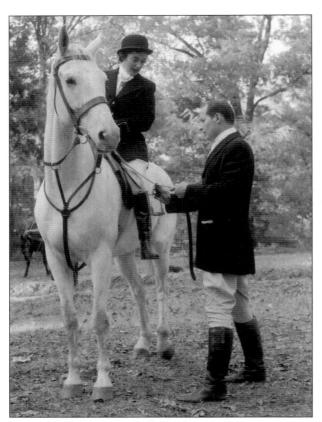

Mr. and Mrs. Frank King were also early members of the Oak Grove Hunt Club. The old fields and woods where the club members rode to the sound of the hounds have been replaced with subdivisions and shopping centers.

Famed writer William C. Faulkner rode with the Oak Grove Hunt Club many times. He would sometimes use another name to play down who he was, but everybody knew he was Mr. Faulkner of Oxford, Mississippi.

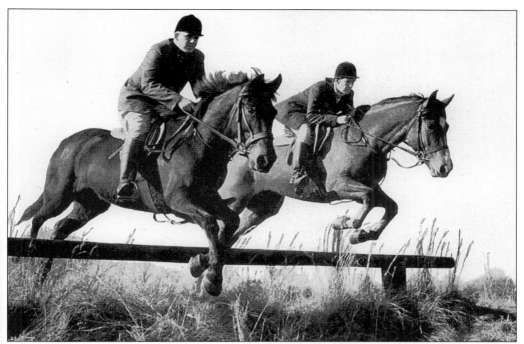

Tom Hunt rides Sir Issac Newton, Mid
South Horse Show Association Champion
in 1964, 1965, and 1966, and Mary Hunt
rides Brewmaster, 1967 Champion. The
Hunts were excellent riders and rode in the
Germantown shows for years.

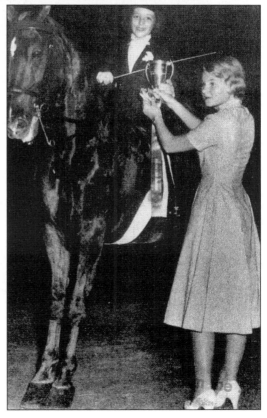

Posey Wrape is presented a trophy by
Gigi Tayloe at the 1952 Germantown
Horse Show.

This fine stock of horses was owned by Wildwood Farms in Germantown. The W.L. Taylor family, owners of Wildwood Farms, had many beautiful horses including polo, hunter-jumper, and harness horses. Both Mr. and Mrs. W.L. Taylor were fine equestrians. They developed the polo fields on Germantown Road and sponsored the first steeple chase in Germantown. At one time, their large barn was the largest barn in Tennessee.

The first Germantown Horse Show president, John R. Stivers, was president three times. He was very dedicated to his position and to the promoting of the horse show.

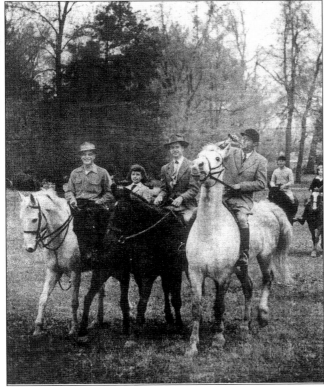

Some of the original members of the Oak Grove Hunt Club enjoy a field ride. Bart Mueller is pictured with his horn and the following are pictured from left to right: (foreground) Claude McCormick, Zetia McCormick, and Lomax Springfield; (background) O.C. Anderson, Cynthia Aden, Peggy Aden, and Margaret Chapman.

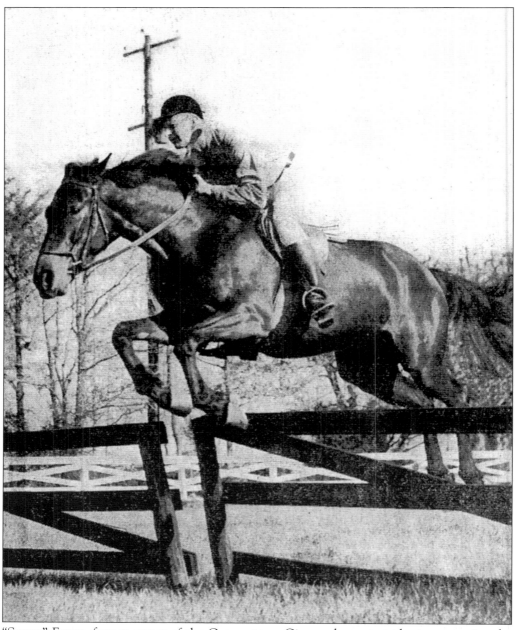

"Sonny" Foster, former owner of the Germantown Gin, made great strides in promoting the Germantown Charity Horse Show and the Oak Grove Hunt Club. For many years, people sought the guidance and training of Mr. Foster concerning their horses and showmanship. He has assisted many young riders as they grew from an amateur to an experienced equestrian. He ranks at the top of his class in professional knowledge and the training and showing of fine horses of all types. Mr. Foster also donned the red jacket and rode to the sound of the huntmaster's horn in the chase for the fox.

The Germantown Horse Show arena is located on Poplar Pike.

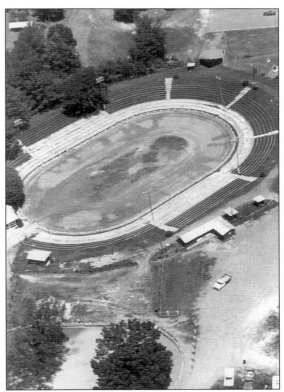

Notice the people standing under the trees at the steeplechase on the old Cotton Plant Plantation, c. 1950.

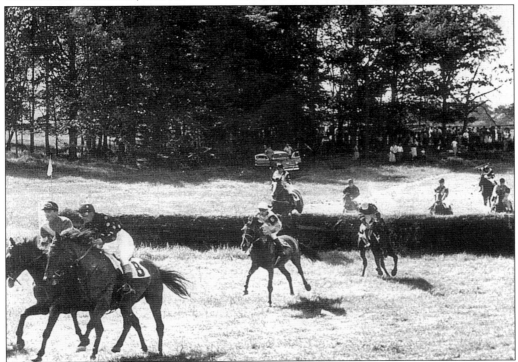

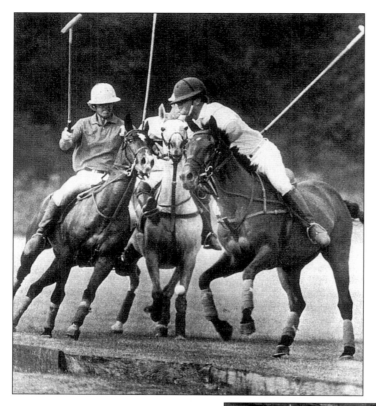

Polo in Germantown began on Wildwood Farms at the home of Mr. and Mrs. W.L. Taylor; the family set up a special field for the sport.

One of the main events for children at the Germantown Charity Horse Show was the pony giveaway sponsored by Mr. and Mrs. Hugh Frank Smith. Mrs. Hugh Frank Smith (Rachael) took great pride in the special pony she selected for the lucky boy or girl who won the drawing. Mrs. Smith was the wife of the noted newspaper columnist Hugh Frank Smith. Mr. Smith entertained his readers for years with many witty and humorous stories in his column "Man of the House." Rachael Smith was also the mother of Olympic Gold Medal winner Melanie Smith Taylor, who has won many honors in the show ring. Rachael Smith taught young people riding lessons for many years at her Germantown horse farm.

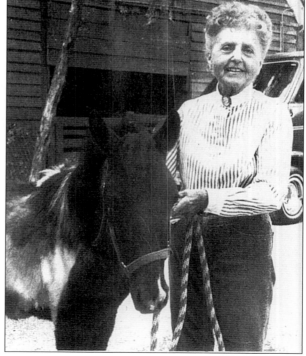

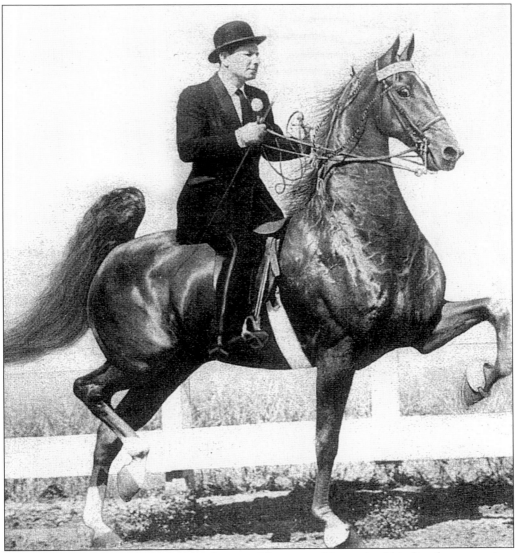

Paul Raines (1920–1989) was born in Lavinia, Tennessee. He received his first fee as a trainer at age 12 and later became known as a superb trainer of American Saddlebreed horses. He has been awarded many honors for showing his horses and also for the horses he has trained for customers. In 1952, he won the World Champion title for his horse Stonewall's Duke of Dixie. Horse and rider also won the Five-Gaited Gelding title in 1952 and 1953 and won the Reserve World Grand Championship in 1952, 1953, and 1954 on Wing Commander. Paul's training skills were well recognized throughout the horseshow industry. He was a master in his profession.

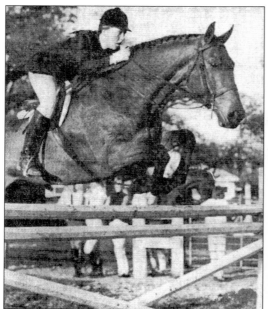
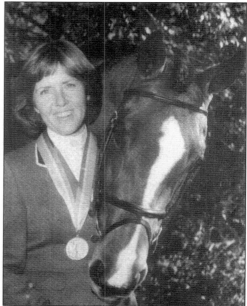

Above left: This photograph shows Melanie Smith on her horse, The Irishman. Miss Smith, born in Germantown, has shown horses all her life. She showed many years in the Germantown Charity Horse Show in the working hunter and open jumper class. Her skills were unmatched by any local rider.

Above right: Miss Smith was a member of the United States Equestrian Team. She won the Gold Medal for the United States in the 1984 Olympics. Melanie Smith and her horse, Calypso, are a "Special Pair" to the town. Miss Smith is now Mrs. Lee Taylor of Germantown.

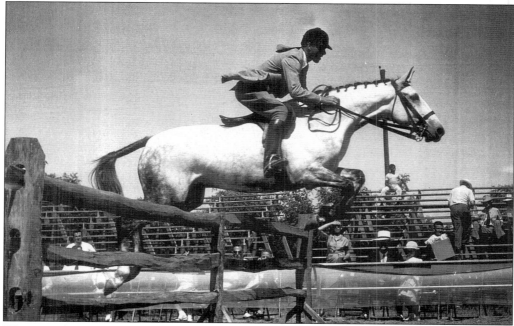

Winston Cheairs, a superb horseman and polo player, won many times with his riding abilities.

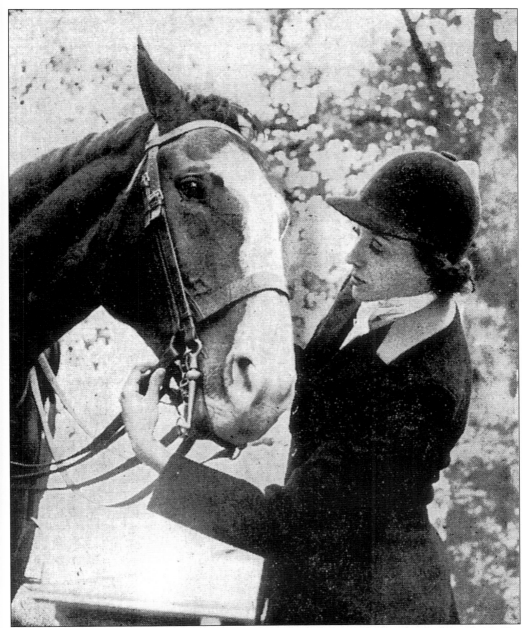

Mrs. Bart Mueller (Mary) was an avid rider in the show ring and also on the hunting field. She prepared many fine meals for the members of the Oak Grove Hunt Club, of which she was a member. Her husband, Bart, is one of the original founders of the Germantown Charity Horse Show and the Oak Grove Hunt Club.

This photograph shows the first horse show arena behind the old gym on the Germantown High School football field. The show was held there for four or five years beginning in 1948.

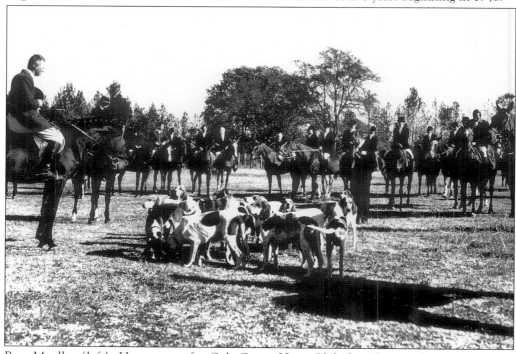

Bart Mueller (left), Huntmaster for Oak Grove Hunt Club for 25 years, knew every trail through Germantown and had keen knowledge of the fox he pursued. He was a tireless club worker, alongside his wife Mary, also a qualified hunter.

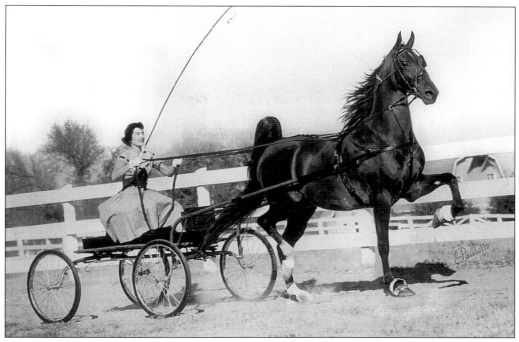

Mrs. Frank King shows fine style and grace in this 1959 photograph of the harness class division

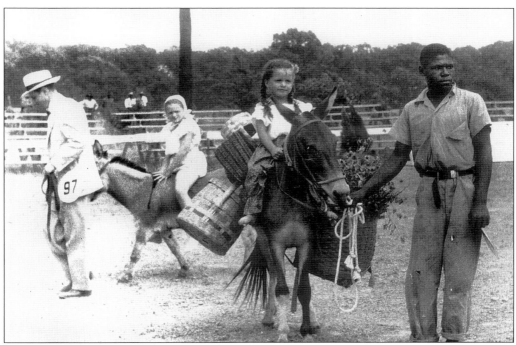

This is a photograph from the very first horse show held in Germantown in 1948. The first horse shows had several classes for children, including a lead-in class where the children rode donkeys. The first shows were held on the football field of Germantown High School.

Two early members of the Oakgrove Hunt Club, Mrs. Jack Erb, mounted on her famed horse, and Mrs. Frank King, stand next to another form of transportation. Both ladies excelled in the show ring.

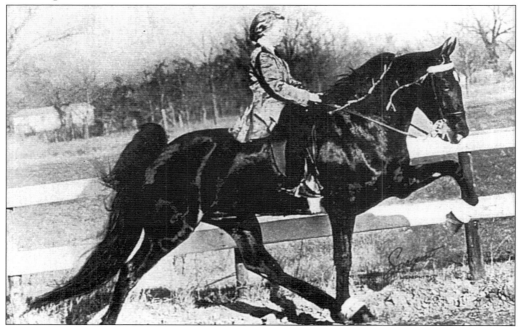

Proud Germantown horse show rider, Brucene Tarkington, shows off her beautiful Tennessee walking horse.

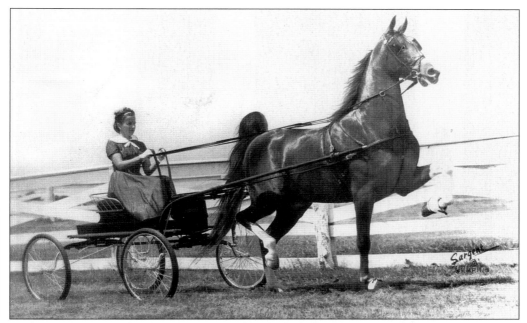

Audry Taylor is photographed with her fine harness horse. Mr. and Mrs. W.L. Taylor of Wildwood Farms in Germantown owned some of the finest horses in the state. She kept a full time trainer at her beautiful stables on Germantown Road.

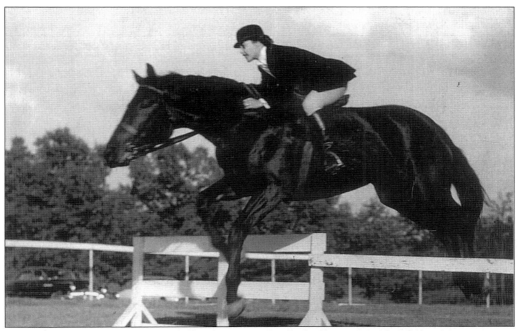

Carroll Russell King was a skilled horsewoman of both the hunting field and the show ring. Her equestrian knowledge is attributed to her grandfather, Perry Russell, who taught her to ride as a young child on his plantation near Clarksdale, Mississippi. Mrs. King is the great-granddaughter of Mississippi Gov. James L. Alcorn.

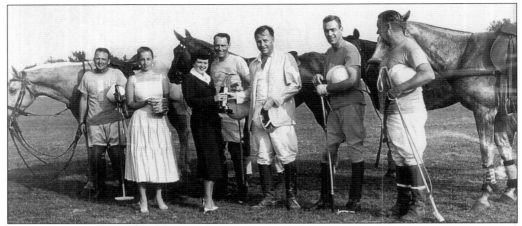

The Germantown Polo Team, pictured left to right, includes Bob Howard, Mrs. W.L. Taylor, Miss Jo Ann Dawson, Eli Long, Winston Cheairs, Robert L. Wilson of Wilson, Arkansas, and Arthur Herman. These team members are receiving their trophies after a Chattanooga-Germantown match in 1956.

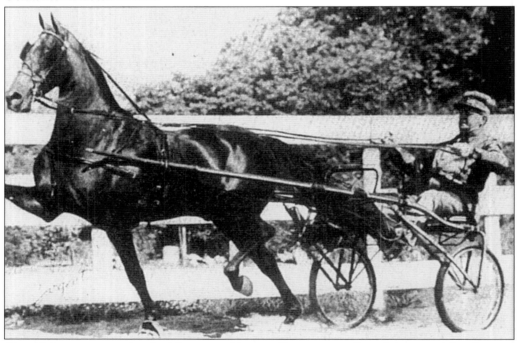

Abe Altfater was associated with top road horses, Tennessee walking horses, and fine harness horses. He accumulated 350 trophies and blue ribbons during his career. Abe was a top amateur driver and his famous horse, "The Aristocrat," thrilled spectators at the Germantown Charity Horse Show for many years. Mr. Altfater also showed in the Celebration, Kentucky State Fair, Louisville, Pin Oak, New Orleans, and several hundred other prestigious shows. His best known walking horse was "The Auctioneer." His famous road mare was "The Duchess," who won the Celebration, New Orleans, and Fort Worth shows and was never defeated under saddle. Abe's horses were under the experienced training of Paul Raines for over 20 years. He was known by his friends and business associates from coast to coast as "Mr. Abe."

Germantown horse show costume class winner, Frank King III, is led by his sister Kathy King; both are children of Mr. and Mrs. Frank King Jr.

Carbon Copy, the World Grand Champion in 1964, was shown as a "special exhibit" many times at the Germantown Charity Horse Show. He was one of the best Tennessee walking horses. After his retirement from the show ring, he was purchased by horse owners in Collierville. Carbon Copy had a unique style unlike any other walking horse. When he appeared in public, the crowds would cheer, whistle, and clap their hands with great appreciation of his fine quality, style, and show abilities. He was a horse that loved the crowds the way the crowds loved him. Carbon Copy was the "Babe Ruth" of the walking horse world.

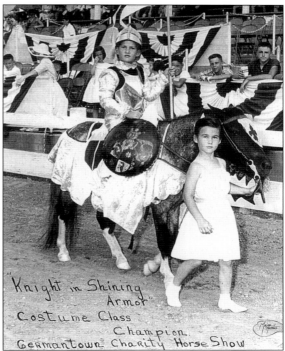

"Knight in Shining Armor" Costume Class Champion. Germantown Charity Horse Show

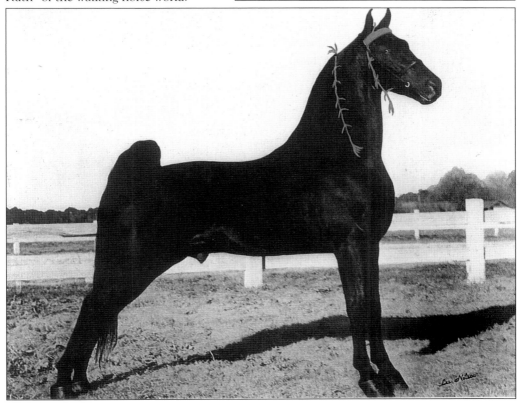

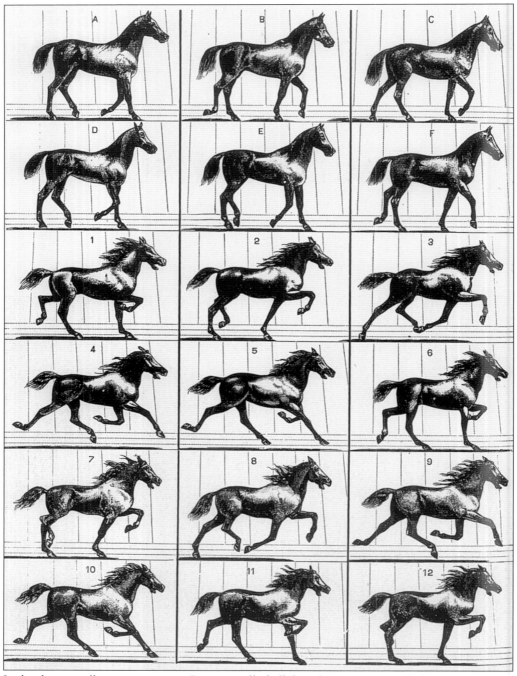

Is this horse walking or trotting? Can you tell if all four feet were ever off the ground at the same time?

Eight
EARLY HOUSES

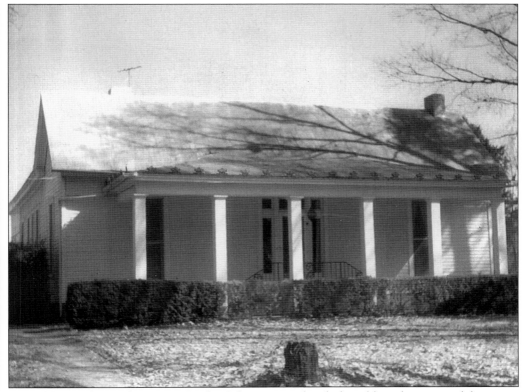

The old Nurnberger home on Poplar Pike is considered the oldest documented house in Germantown. It was built in 1828 by Randolph Webb of North Carolina. The house has served as a private school for boys as well as the home of the Webb family. During the mid-1800s, the Webb School for Boys flourished. It later became a coeducational community school. This was the beginning of the Webb School in other Tennessee locations.

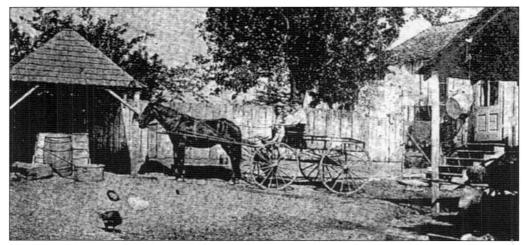

The Lucy home, in the center of Germantown, was near the Germantown Depot. Here, the Lucy children pose in their family carriage. Notice the old oak barrels and the wash tub next to back door.

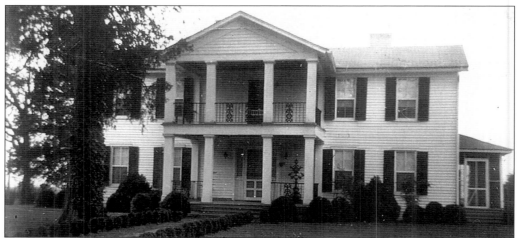

This fine old home on the Cotton Plant Plantation belonged to the Kimbrough family for over 100 years. James Titus, the first owner, acquired the land through a land grant and built this home in 1820. James Kimbrough purchased the home, along with 1,100 acres of land, for $11,000 in 1835. The plantation produced cotton and corn and was the largest in land size and slave concentration in Germantown. It was manned by a force of 88 slaves. The property was located on the old Germantown-Capleville Road two miles south of Germantown. Later, the plantation grew to contain 1,600 acres. In 1860, this plantation had 700 acres of improved land, 900 acres of unimproved land, 1 horse, and 19 mules. The same year the Cotton Plant Plantation produced 215 bales of cotton, more than any property in Germantown. The cash value of the farm was $35,000. One story of the old home is of five Union soldiers who ransacked the home during the Civil War while being stationed in Germantown. During their plundering they discovered $20,000 in silver that had been stored in a tobacco box under a dormer window. While dividing the contents their field commander discovered what they were doing and demanded to know where they had gotten the money. He ordered the men to return the money to Mrs. Kimbrough because of her former generosity to Federal soldiers. The old home burned in the 1950s

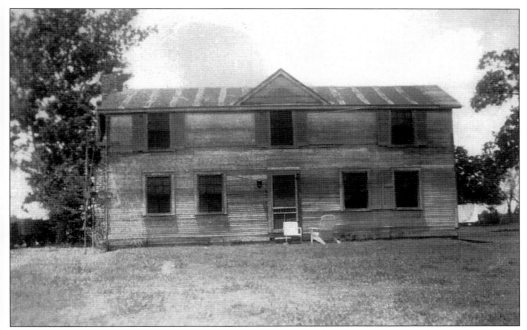

The early Riverdale Road farm house was owned by the Ingram Howard family. Mr. Howard was not the original owner, but he made numerous improvements to the property and home. The other picture shows the improvements he made to the house. Mr. Howard operated a dairy on his Riverdale farm for many years.

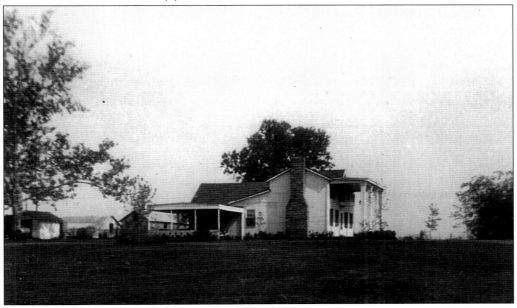

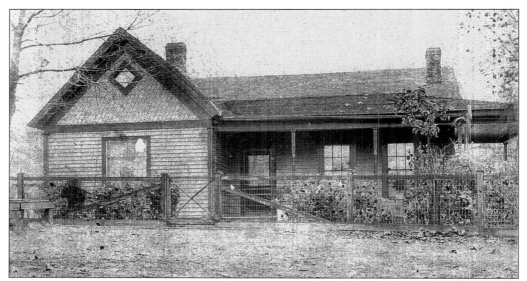

This photograph shows the Lane home in Germantown. The Lane family has a long history in the town. Jeff Lane's parents were brought from Virginia as slaves of the Callis family. Julia and Irene Lane's grandmother was the cook on the Callis plantation. The Callis's were good to their slaves and the Lane family stayed with the Callis's after the Civil War. Julia and Irene Lane both received their bachelor's degrees from Lane College in Jackson, Tennessee. Irene taught school for a number of years in Memphis and Julia was a second grade teacher at Nashoba School in Germantown and later at Riverdale. She taught school for about 40 years. The Lane family has owned their home in Germantown for over 100 years. Their father would haul cotton by wagon from the Callis Gin to Memphis and deliver groceries and ice back to the Callis' store in the evening. He worked for C.M. Callis for many years.

Maude Cauthorn built this home known as The Pines on Poplar Avenue at the site of the current Methodist hospital and medical office buildings. The bricks are believed to have come from the former Mississippi plantation of Jefferson Davis. The Christmas tree that Germantown puts the lights on each year was in the front yard of Mrs. Cauthorn's house. Later, the home was sold to Dr. William F. Bowld of the Bowld Hospital in Memphis. It also was an antique shop, bookstore, tea room, and feed store. The Pines sat on 15 acres.

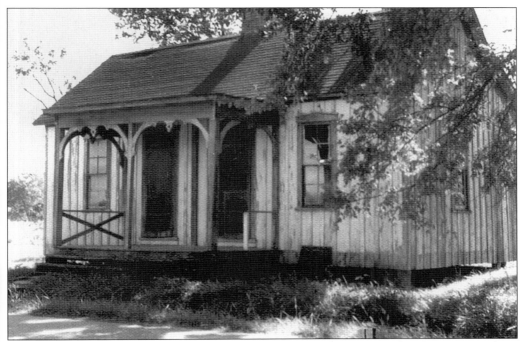

This old railroad section house is an example of the homes built for railroad repairmen along the railroad in Germantown and other areas.

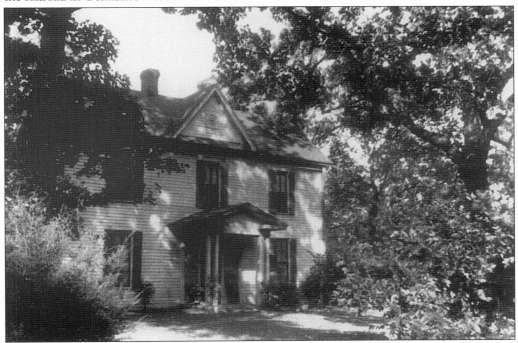

Shannondale, the home of Charles Shannon and his wife, was located on Poplar Pike in the Ridgeway community. The old home stood for many years before it was torn down in the late 1960s.

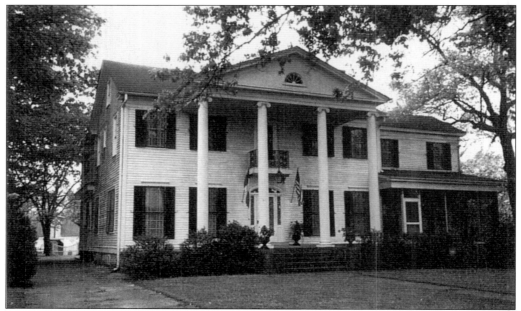

The W.N. "Sonny" Foster home was built in 1905 on Germantown Road. The house was constructed by James Coan, manager of the Sterling Brewery in Memphis. Mr. Coan lived in Memphis, but moved to Germantown where his children went to Germantown High School. At one time, his property contained about 40 acres.

This is a photograph of the Barry residence around 1832. Thomas L. Moody, a blacksmith, built a double log cabin on his land and in 1899 Squire John Lafayette Coopwood, a planter, and his wife purchased the property. Their daughter, Bessie, married Jack W. Barry, a cotton broker who served as mayor from 1930 to 1954, longer than anyone in the city's history.

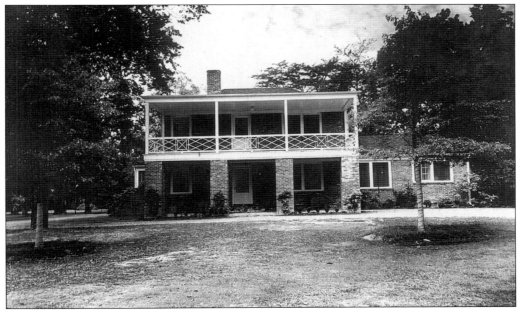

The L.B. Lary home was built in 1947 on the original foundation of the famed Frances Wright Nashoba plantation house. The original home faced Poplar Pike and the Lary's built their home to face Riverdale Road. The cedars that were in front of the original home were planted by Frances Wright and her slaves.

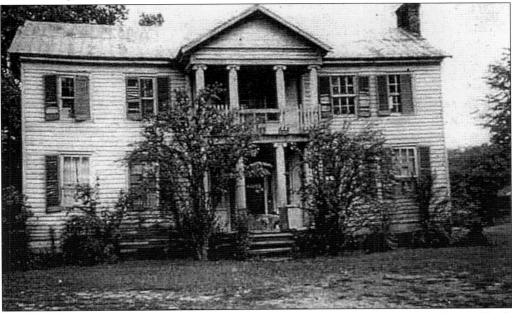

In 1834, Wilks Brooks purchased 640 acres on the Cherokee Trace, now Poplar Pike, and built this beautiful home, "Woodlawn." This plantation home was used as a hospital during the Civil War. It is still intact and listed on the National Register of Historic Places. Mrs. Walter D. (Dorothy Kirby) Wills Jr. and her son Walter D. Wills III have totally restored the home. They are descendants of the Brooks family.

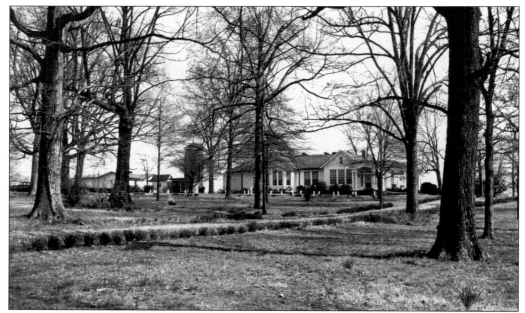

Moses Neely's home, located on the old Germantown Road, was the scene of several small engagements during the Civil War. Moses Neely was the progenitor of the Memphis Neely family. The property was later purchased by "Bald Eagle" Renthrop, a famous wrestler and wrestling promoter.

This is the house where William Clayton, the Germantown High School custodian, lived. The home was owned by Joseph B. Kirby. All the students like Mr. Clayton, an Irish immigrant; at Christmas time the students would take a donation to buy a fruit basket for Mr. Clayton.

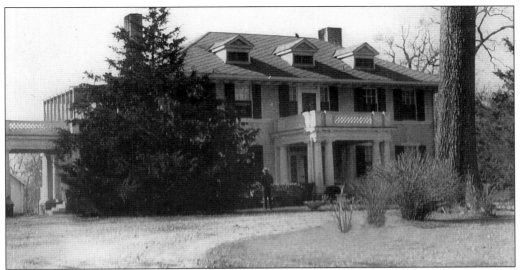

Col. James T. Hammond, publisher of the *Commercial Appeal*, owned this home known as Mimosa. Built by Peter G. Grant in 1924, the home was originally called Grantland and sat on 50 acres of land. Mr. Hammond purchased the house and 50 acres and put deer on his property. He also owned Cotton Plant Plantation at one time and later sold it to Ned Cook. Mimosa, a southern colonial home, burned in 1945. Mr. Hammond was a merchant, planter, and real estate developer. He owned the Sterick Building in downtown Memphis.

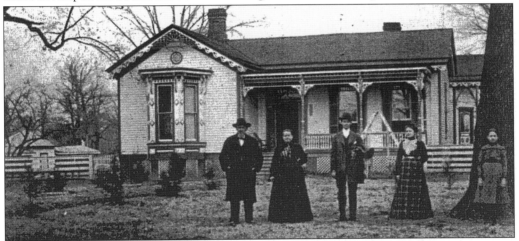

Pictured in front of the Kirby House are John Anderson Kirby, Ann Eliza Brooks Kirby, Joseph Brooks Kirby, Merle Williams, and Agnes Rebecca Kirby. Part of the old Kirby House on Poplar Pike was built in 1834 by its first owner, Col. Eppy White. He sold the house and 143.5 acres of land to Wilks Brooks of Woodlawn Plantation in Germantown in 1838. Some family members say Joseph Brooks, son of Wilks Brooks, lived in the home. Other family members say Wilks Brooks used it for his overseer's house. In 1853, Joseph Brooks sold the property. The property was sold nine times before 1869 when Thomas A. Nelson of Memphis purchased the property. Mr. Nelson was in the cotton business, insurance business, and banking industry. In 1898, the property was sold to John A. Kirby. It has been in the Kirby family ever since. It is currently owned by Mrs. Walter D. Wills Jr. (Dot Kirby Wills) and her son Walter D. Wills III. Mrs. Wills is the granddaughter of John A. Kirby.

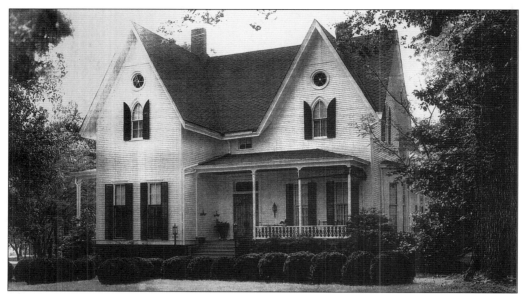

This photograph shows the Messick house, which stood a short distance to the west of Kirby Road. Built in 1870, the home was known as Greenlawn Plantation. It was located on 450 acres of land. Messick High School in Memphis was named for Elizabeth Messick, a member of this pioneer Shelby County family.

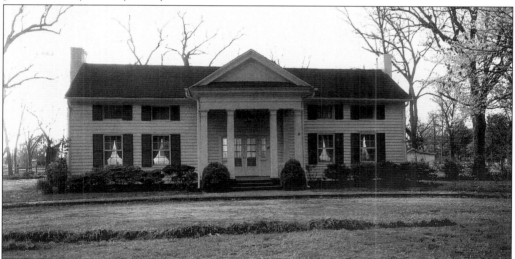

The home known as Richmond on the outskirts of Germantown was built between 1837 and 1840. Daniel Riggs, the owner, purchased the property in 1837. The house and land were sold many times before being acquired by Dr. and Mrs. Leonidas Polk Richmond in 1860. Dr. Richmond traveled on horseback and covered Germantown, Forest Hill, Cordova, and Olive Branch. He joined the Confederate Army as a surgeon and served three years. After the war, he farmed the land and reared nine children. Originally, this house was a typical dogtrot cabin. Dr. Richmond redesigned the cabin by adding the painted weatherboard, dentil moulding, shutters, and a columned porch. There were also many changes to the interior of the house. Mr. and Mrs. Reeves Hughes owned this fine old home for many years. They did extensive work in preserving and restoring the house and the property to look as it does today.

Nine
EARLY POPLAR & GERMANTOWN ROAD

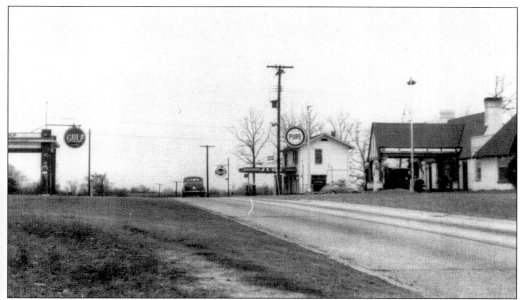

This view looks west at the intersection of Poplar Avenue and Germantown Road in 1939.

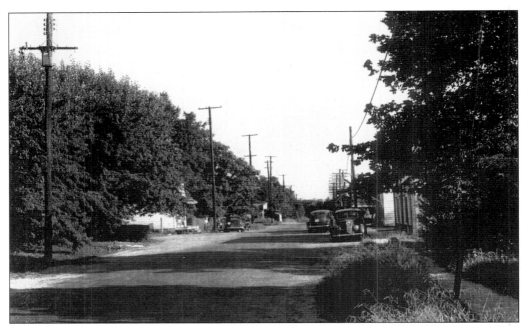

Germantown Road has had many names; it was originally named Bridge Street, then Germantown & Olive Branch Road, then Germantown & Cordova Road, and finally Germantown Road. This 1940 photo shows Germantown Road near the old Hot Tamale Road, now called Dogwood Road.

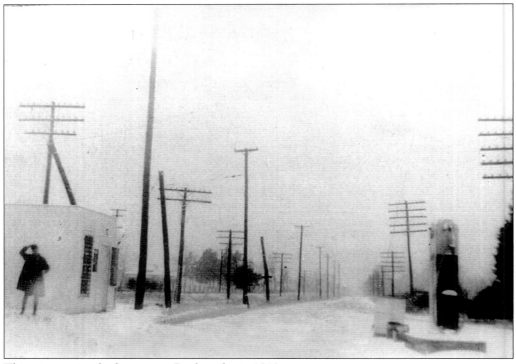

This winter view looks west on Poplar pike in 1943.

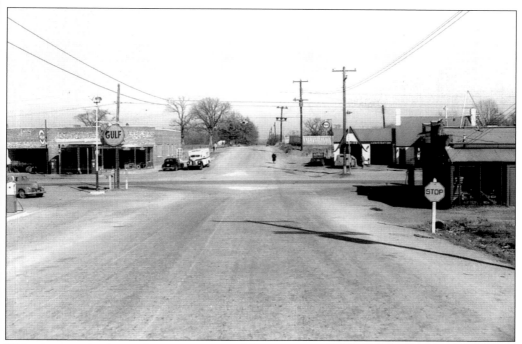

This photograph shows the intersection of Germantown Road and Poplar Avenue looking north, c. 1940.

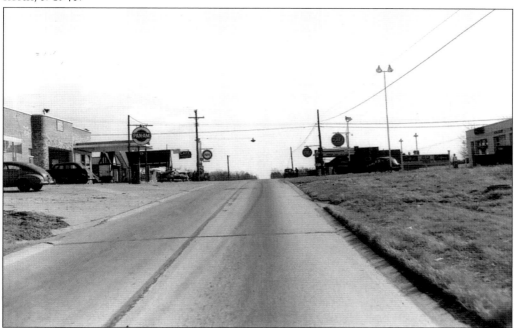

This early 1940s photo presents Poplar Avenue and Germantown Road looking east. On the right side is the Gulf Service Station and on the left are PanAm, a café, and Pure Oil. Hopper's Grocery, which sold Gulf gasoline, is the red brick building on the right with the canopy out front. Notice that Poplar Avenue is only two lanes wide.

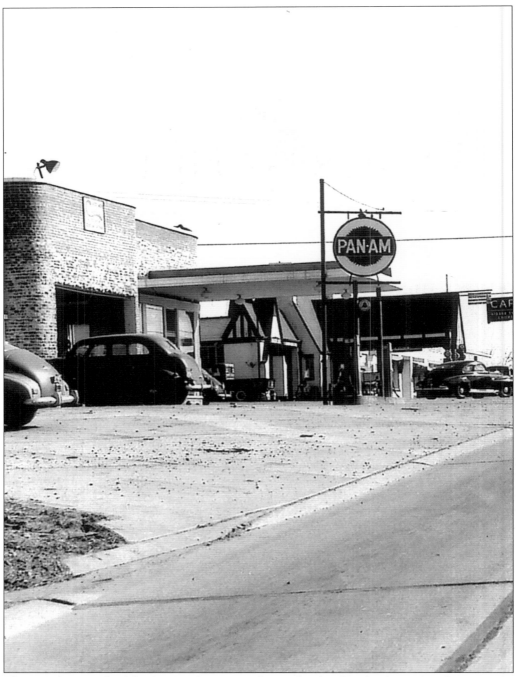

This is a photograph of the PanAm Station on the north side of Poplar Avenue at Germantown Road. Hopper's Grocery also used this building, *c.* 1940.

Ten

FOREST HILL

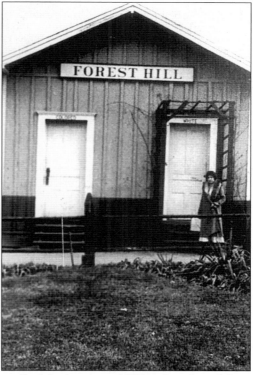

Above left: Joseph W. Skinner was born in Ruckersville, Mississippi, in 1870 and graduated from Mississippi Heights in Blue Mountain, Mississippi. He first owned a large plantation in the Buntyn section of Memphis. In 1908, Mr. Skinner and his family purchased a large section of land on Forest Hill Road at Winchester. Here, his dairy cattle supplied the milk for his Memphis dairy, the Forest Hill Dairy. Mr. Skinner operated this successful dairy for many years. His son ran the dairy until it was sold to Dean Foods.
Above right: This is a photograph of Forest Hill Depot in 1928.

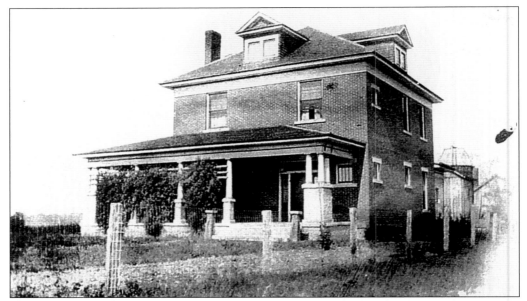

The Joseph W. Skinner home and farm were located on Forest Hill Road near Winchester Road. Mr. Skinner was the owner and founder of the 640 acre dairy farm that he named Forest Hill Dairy. This was a very successful business that operated in Memphis for many years. The milking plant was on Forest Hill Road. In the beginning, the business was operated by horse-drawn wagons. Mr. Skinner owned the largest dairy in Shelby County and the first to use motorized vehicle transportation for dairy delivery.

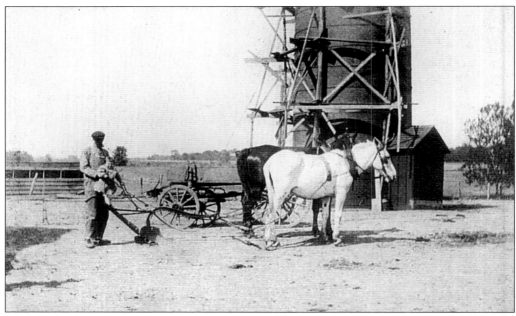

This 1912 photograph shows workers getting ready to plant cotton or corn on the Skinner, which consisted of 640 acres of land.

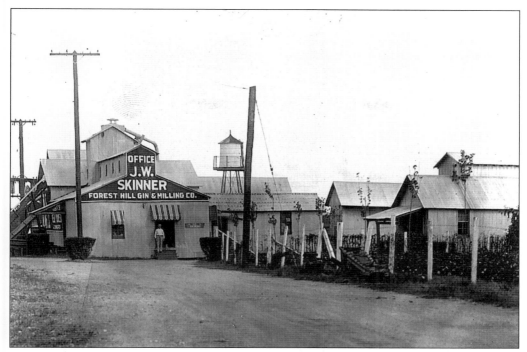

Mr. Skinner built and operated the J.W. Skinner Gin and Milling Company in 1924. It stayed in operation until it burned in 1948. Mr. Skinner then sold this property and moved to Collierville where he built a new home and gin.

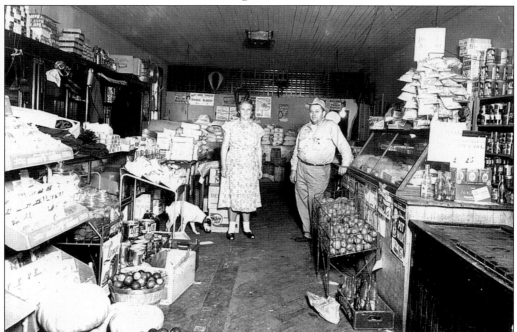

Mr. and Mrs. M.U. Scott are pictured at their general store in Forest Hill. The store is Belmont Grill. Mr. Scott also sold gas; he did a fair amount of business for many years.

The Forest Hill Drive-In Grocery and Bait Shop was known as Pirtle's Service Station in the 1930s and 1940s. The Pirtle family lived in the back of the store. It remained in business in the 1980s and was one the only place in town that sold fishing bait. It has now been torn down and replaced by a gas station.

This photograph shows First Hill Drive-In Grocery as it looked in 1980. The store has always done a large volume of business because it is the halfway point between Germantown and Collierville.

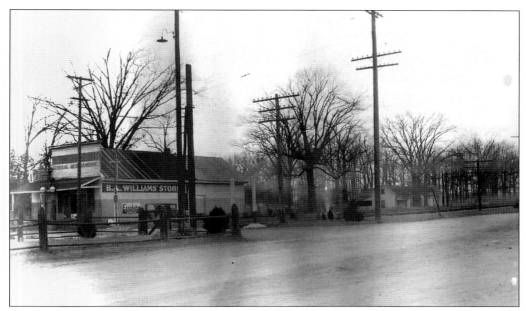

The Ben Williams General Merchandise Store of Forest Hill was probably the very first store in Forest Hill. The wooden store stood for many years on the southwest corner of Forest Hill Road and Poplar Pike, just south of the Southern Railroad tracks. It was the largest store until the Moorer Store was built on the northwest corner of Poplar Pike and Forest Hill Road.

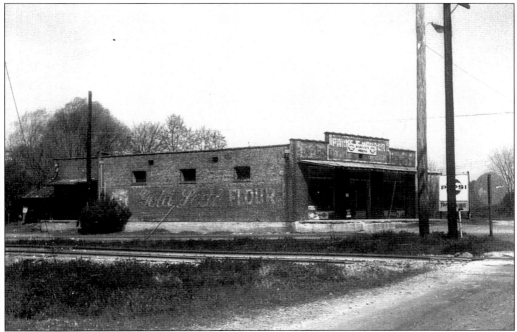

The Moorer Store, built about 1912, was the largest store in Forest Hill during its day. It sold everything for the home and farm. The large brick building also housed the Forest Hill Post Office for many years. Tenant farmers that Mrs. Moorer "furnished" would line up in wagons and buggies along Old Poplar Pike and Forest Hill Road to do their trading.

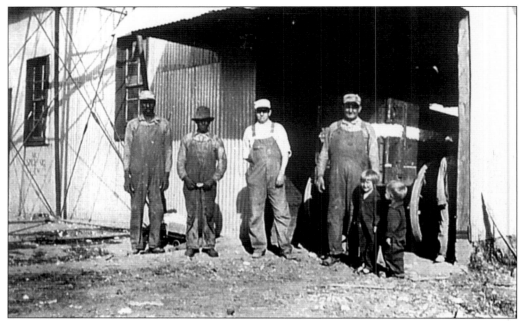

Employees of the J.W. Skinner Cotton Gin in Forest Hill are pictured c. 1940. Mr. Skinner had a very large gin business in Forest Hill from 1924 to 1948. His gin burned in 1948; he then moved to Collierville and built a new gin.

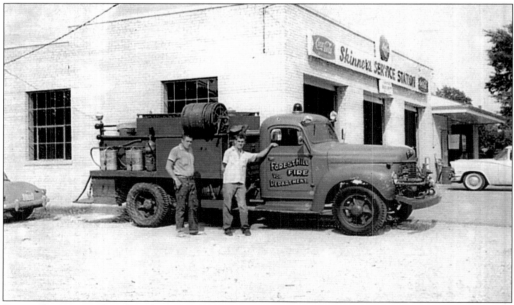

Dave Skinner and a friend are pictured standing next to Forest Hill Fire Department fire truck in front of the Skinner service station in 1959. Mr. Skinner owned a large farm on Forest Hill Road and, operated the J.W. Skinner Gin & Milling Company with his father. Dave Skinner was an excellent automobile mechanic and welder. He did his own gin repairs and skilled craftsmanship on his farmhouse. Dave Skinner was a trained pilot; he built an airstrip on his property.

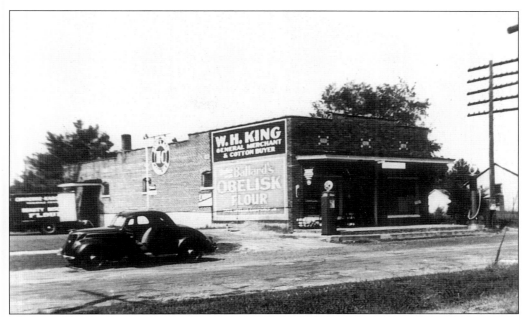

The W.H. King Store was the first store in Forest Hill or Germantown to have a meat locker. This store was located on Poplar Pike behind the Moorer Store. Mr. King was also a cotton buyer.

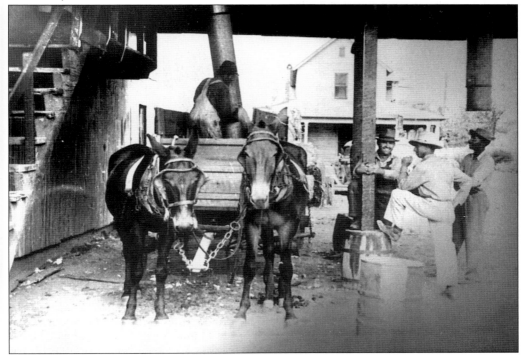

This 1945 photograph shows cotton being unloaded from a mule-drawn wagon by the sucker pipe at the J.W. Skinner Gin. Most gins today do not have this type of system. The new method is a modular bale system; however, some older gins still unload with the sucker pipe.

Mr. Joe Wright and Dr. Jewel Clark are pictured in Forest Hill in 1912. In 1915, Dr. Clark, a young doctor who had married his nurse, came to Forest Hill to live and practice his profession. The young people liked to ride with him on his calls. He served the community until 1965.

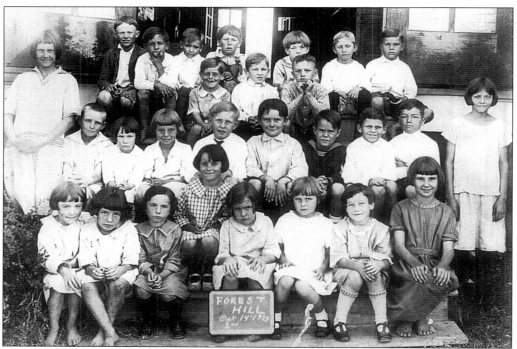

Note that some of the children in this Forest Hill School second grade class of 1924 are bare-footed.

The Forest Hill Baptist Church was built 1925.

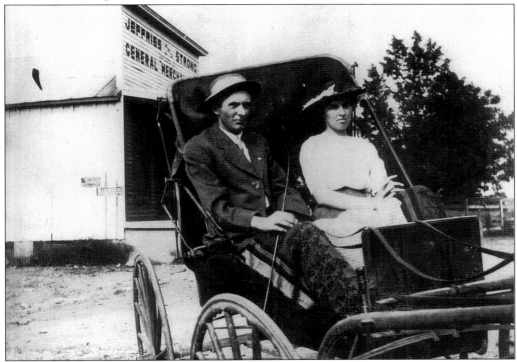

Sellars Fletcher and Electra Jones are pictured in a buggy in front of Jeffries and Strong General Merchandise Store in Forest Hill. Notice the buggy has rubber tires.

The Forest Hill Post Office was located in the Jeffries and Strong General Store.

Opened in 1912, Moorer General Store sold nearly everything needed for the home or farm, including items such as horse collars, saddles, kerosene lamps, plow lines, harnesses, wash tubs, overalls, work shoes and boots, and groceries. It was the largest store in Forest Hill.

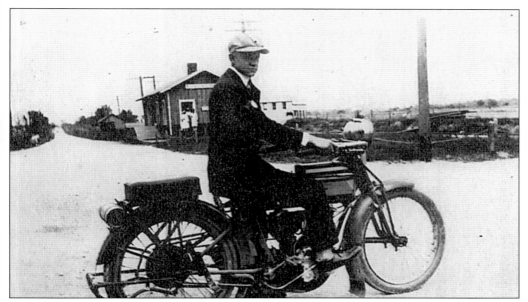

Dave Skinner, son of J.W. Skinner, owned a large farm in the Forest Hill area. He also owned a gas station and garage where the Exxon station is located today on Forest Hill and Poplar Avenue. Notice the old Forest Hill Depot in the background on Poplar Pike next to the Southern Railroad.

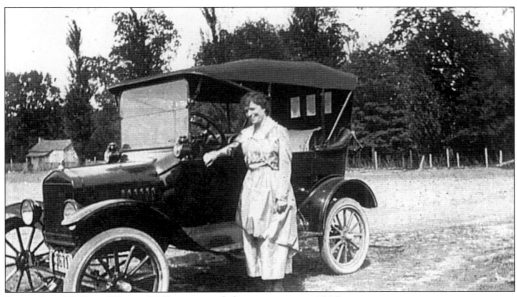

Betty Cox Hollis of Forest Hill poses with her new car, c. 1918.

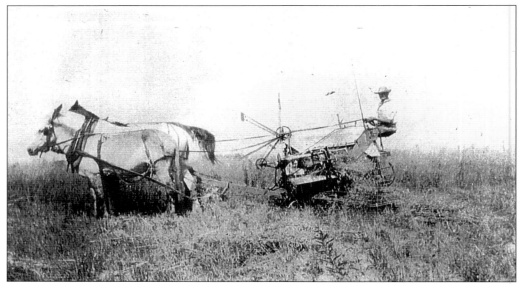

This 1912 photograph shows an early wheat cutting machine being pulled by three large draft horses. The J.W. Skinner farm was one of the largest farms in Forest Hill. The Skinners always had some of the best and newest machinery of anyone in the area. They were good farmers and also ran a profitable dairy business for many years.

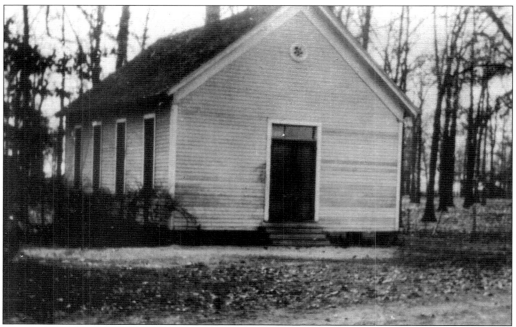

The first log school house in Forest Hill also doubled as the Forest Hill Baptist Church. In 1913, the new Forest Hill School, which is now the Forest Hill Theater, was built. The Baptist Church used the old school house for their church until 1925, when they moved to their new location.

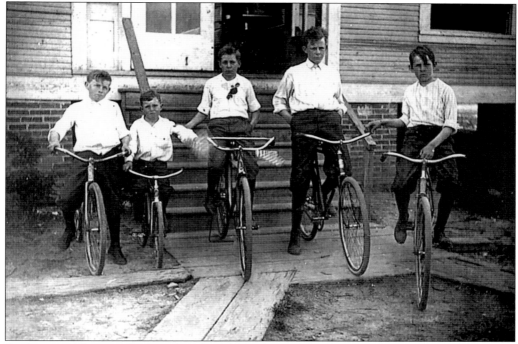

Students are photographed on their bicycles in front of the Forest Hill School.

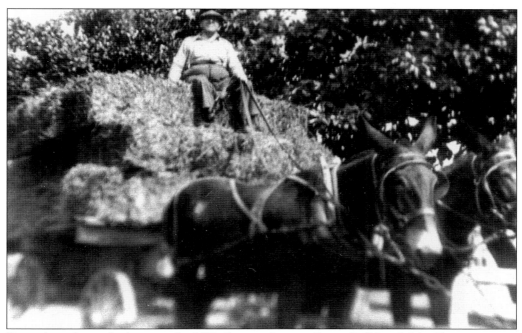

Hay is brought to the barn on the J.W. Skinner farm on Forest Hill Road. Mr. Skinner, owner of Forest Hill Dairy in Memphis, was quite a large farmer and ran the J.W. Skinner Gin & Milling Company in Forest Hill.

The Neville Home was located in Forest Hill where Old Poplar Pike and Poplar Avenue merge. Neville was a large farmer in the area and later opened his home as a stagecoach inn for travelers on their way to Memphis. This was the last inn along the route before reaching Memphis. The home still exists, but it has been moved to Raleigh-La Grange Road in Collierville.

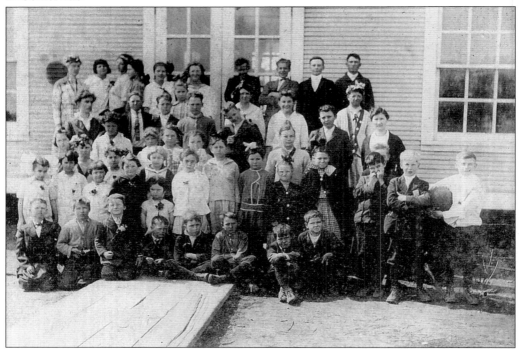

The third, fourth, fifth, and sixth graders at Forest Hill School are photographed in 1920. Notice the wood plank path to the front door. Brick was later added to the walls of the original wooden building.

Eleven

AGRICULTURE

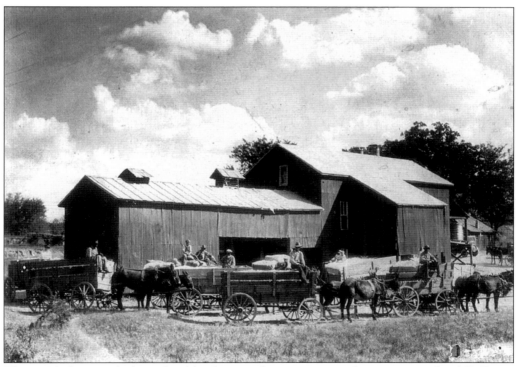

This 1935 photograph shows local land owners lining up to gin their cotton at the A.P. Foster Gin Company. Each wagon could haul about one bale of cotton per load. Mr. A.P. Foster could identify who was coming to the gin by recognizing the team and the wagons.

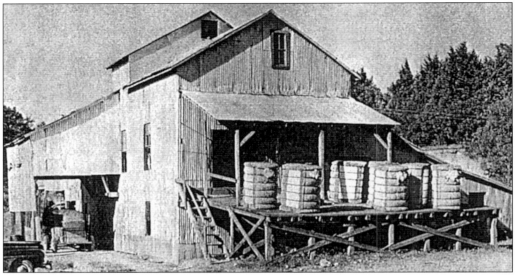

In 1912, C.M. Callis built a cotton gin behind the Masonic Lodge on Germantown Road. Each year the gin would produce 900–1200 cotton bales, which were loaded onto boxcars on the Southern Railroad. In 1928, A.P. Foster bought the gin from Mr. Callis. It was then known as the A.P. Foster Gin & Coal Company; Mr. Foster and his son, W.N. "Sonny" Foster ran the gin. They also operated a sawmill, grist mill, and coal yard from this same location. The gin was in full operation until 1965.

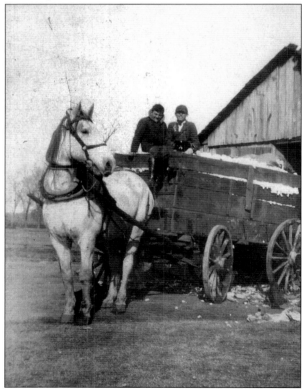

This *c.* 1945 photograph taken at the Howard Dairy Farm on Riverdale Road shows some of Mr. Howard's tenants delivering cotton to the storage barn. Notice the large, stout draft horse.

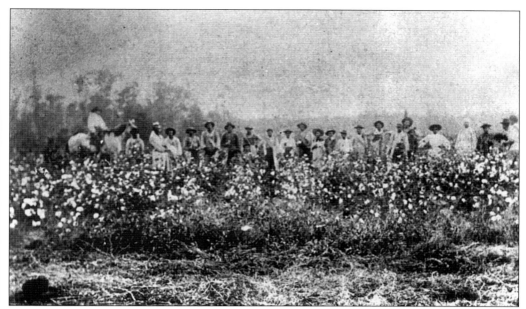

This was a familiar scene in the early days of cotton farming. Shown here is the overseer on his horse with his picking crew on Riverdale Road in 1925.

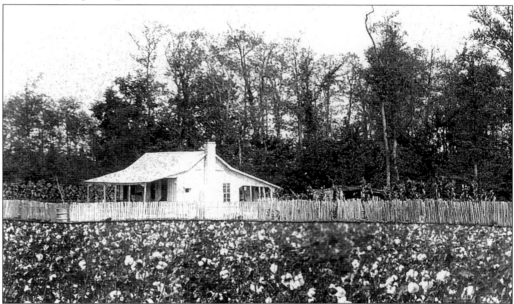

This farm manager house was located on the Homer K. Jones farm on C.D. Smith Road. Mr. Jones was a CPA in Memphis and operated a farm in Germantown. He later moved to this 640 acre farm. There were 14 families living on the Homer K. Jones farm in the 1940s. Jones was quite a sportsman and horseman and owned several good hunting dogs. Many of his hunts were on horseback. He raised quail and pheasants for hunting on his farm. Jones's accounting firm in Memphis also had branch offices in Washington, D.C. He was one of the first licensed CPAs in the state of Tennessee. Mr. Jones also had a chauffeur to drive him where he wanted to go. He was partial to black Cadillac and Lincoln automobiles.

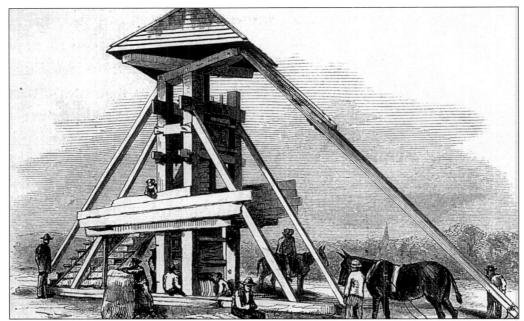

This is an early type of cotton press used on large plantations in the South before the Civil War. Two mules would be connected to the long wooden poles called buzzard wings on each side. The cotton was loaded from the top and compressed by the turning of a large wooden screw or press forming the bale.

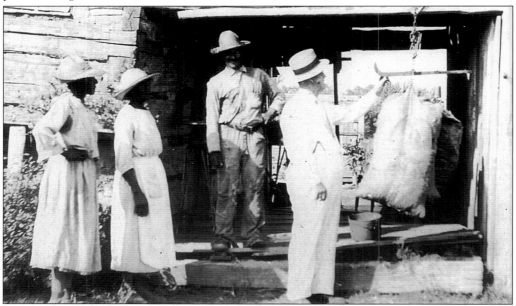

This photograph shows weigh-in time at the Homer K. Jones farm, Germantown's largest farm in the 1940s. This style of cabin was called a dogtrot cabin. A steelyard scale was used to weigh the cotton. A good tenant could pick 100 pounds of cotton in a day. Only 10 percent of all cotton pickers could pick 200 pounds per day. In 1945, the going rate was $2.00 per hundred pounds of cotton picked.

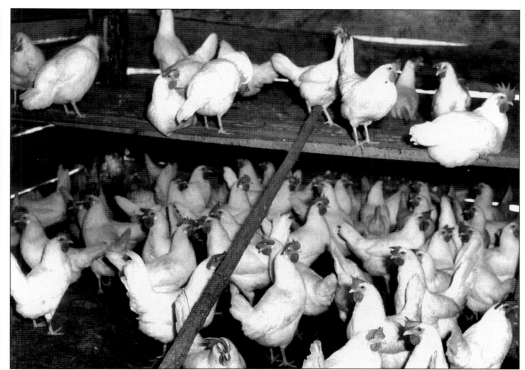

The chicken house on the Homer K. Jones farm was quite large and supplied all of Mr. Jones's tenant families year-round. Mr. Jones was profitable in selling eggs as well as poultry.

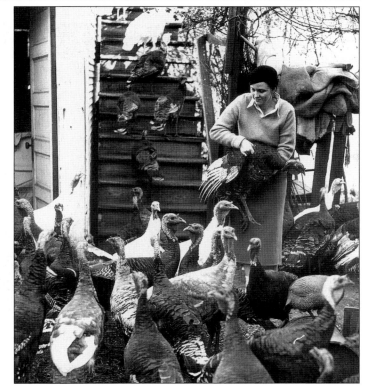

This turkey farm was near the old Cordova Road in Germantown. In the 1940s, Germantown had several large poultry farms.

Workers are captured taking a break at the Callis Farm on Callis-Cutoff Road. Break time for men and mules on most large farms was from 12 to 2 p.m. This gave both the laborers and mules time to eat, cool off, and rest before plowing more land in the afternoon.

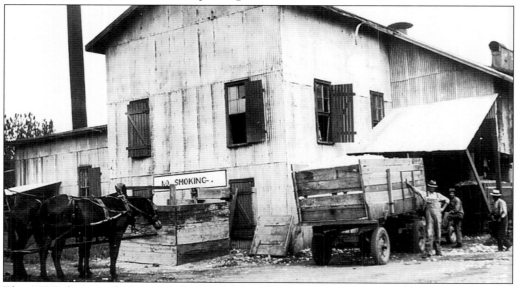

This 1937 photograph shows a side view of the old A.P. Foster Gin & Coal Company. This gin was in operation from 1912 until 1965. Mr. A.P. Foster and his son, Sonny Foster, owned the gin from 1928 to 1965. Mr. C.M. Callis was the original owner.

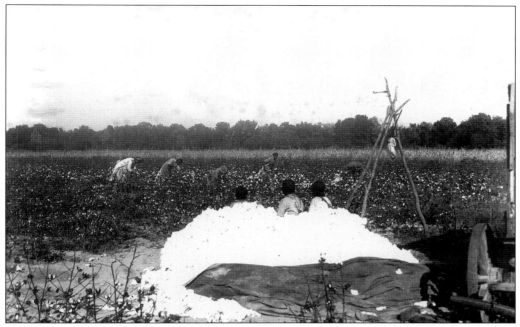

Children sit on a high mound of cotton and watch as their parents pick cotton on this Hacks Cross Road farm. The tripod is where the scales were set to weigh the amount of cotton picked before it was added to the pile in the wagon. A good picker could pick 100 pounds or more a day.

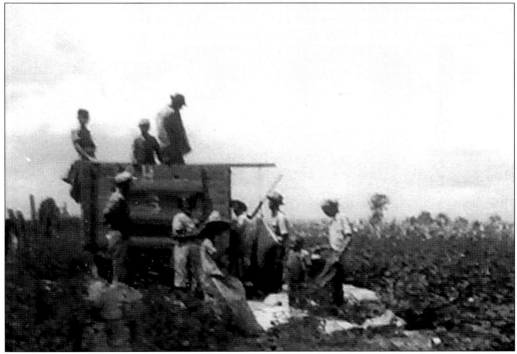

Workers farm the Homer K. Jones place along Hacks Cross Road.

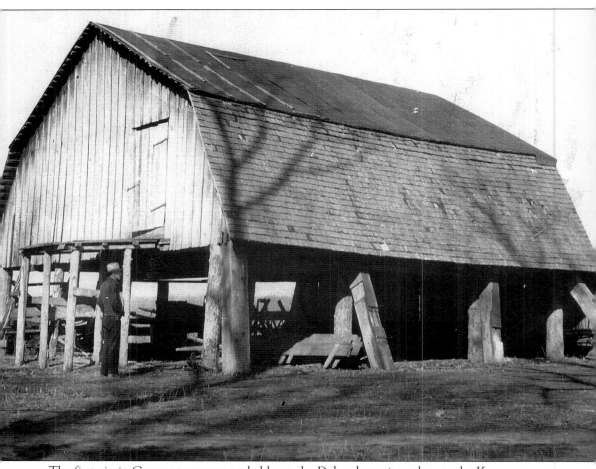

The first gin in Germantown was probably on the Duke plantation, close to the Kroger store on Poplar Avenue and Kirby Road. The gin was run by mule power. This property was later bought by Harvey Firestone of Firestone Tire & Rubber Company.

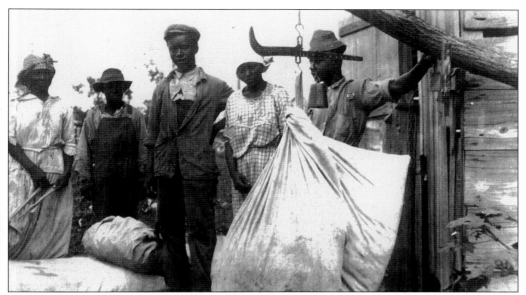

Cotton pickers get their cotton weighed at the Wolf River bottoms in 1942.

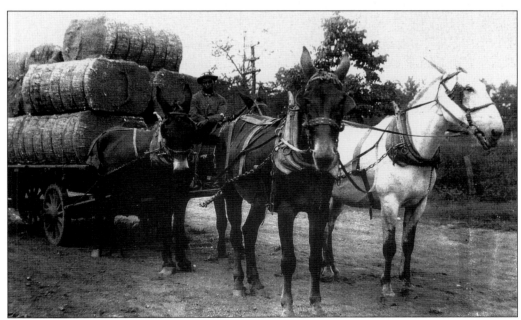

In the early days of cotton ginning, cotton was transported from the gin to the railroad for shipping. This photograph shows a four-mule team transporting the bales to the railroad. Each bale weighed 500 pounds.

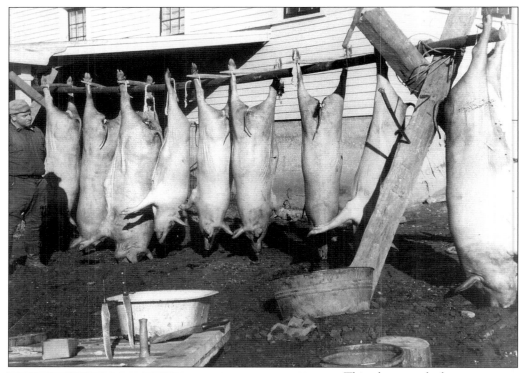

This photograph shows hog killing time at the Homer K. Jones place on C.D. Smith Road. Hog killing was done on a real cold day. The hogs were then placed in a smoke house and the bacon and hams fed the landowners, his family, and all the farm tenants for the winter. Notice the hog scraper on the table.

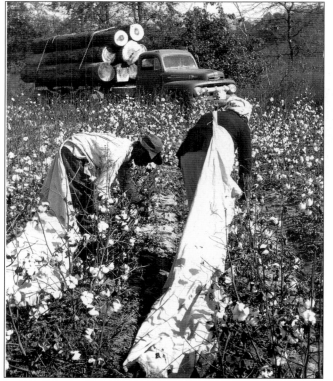

Cotton is picked along Germantown Road in 1948. Long sacks were drug behind each picker. When the sack was full or too heavy to carry, it was weighed in the field and placed in the cotton wagon. Logging was also very common in the river bottoms around Germantown.

Twelve
RIDGEWAY

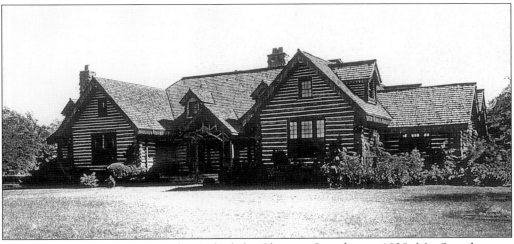

This beautiful home "Annswood" was built by Clarence Saunders in 1928. Mr. Saunders was the founder and owner of the Piggly-Wiggly food store chain. This ten-room log home was located in the center of Saunders's private resort. He also built a golf course, Olympic-size swimming pool, guest cottages, horse barns, and servant quarters. The home was quite elegant on the inside; spacious rooms, three marble fireplaces. lots of paneling, 24-foot vaulted den ceilings, pegged oak floors, fancy door and bathroom fixtures, and beautiful lighting. Saunders previously owned the Pink Palace on Central in Memphis, which is now a museum. He lost both Annswood and the Pink Palace because of financial problems. This home was later sold to famous baseball player Bill Terry of the New York Giants. Mr. Terry converted the 77 acres into a farm and dairy.

George C. Bennett of Ridgeway Farms was a bookmaker and owner of a string of horses. His best horse was Abe Frank, winner of the Tennessee Derby in 1909. Born in Mobile, Alabama, George C. Bennett moved to Memphis in 1890 and opened a pool room in the old Park Hotel, opposite Court Square. Bennett bought Ridgeway Farms in 1896 and began training race horses. After his racing career, he operated a dairy farm. He was known coast to coast, in Canada, and Mexico as a horseman who trained winners. His horse, Dishabille, carried several eastern sweepstakes. Other winners from Mr. Bennett were Aladdin and Rhett Goode. His home, Ridgeway Farms, was regarded as a model country place in Western Tennessee. Mr. Bennett was also in the real estate business.

Harvey Firestone and Harvey Firestone Jr. of the Firestone Tire & Rubber Company purchased the old Duke plantation in the Ridgeway area. The Firestones lived there for many years and developed the Duke place into a model country estate. The Firestones were very fond of horses and rode for many years all over Germantown, c. 1950.

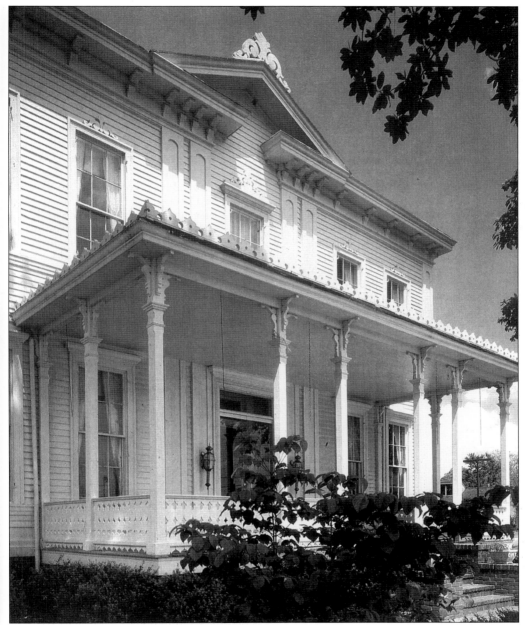

The Mosby-Bennett house in Ridgeway was built on 2,000 acres of land in 1852. This three-story home was originally owned by Joseph Mosby. Years later, race horse owner George C. Bennett purchased the home and 1,500 acres. The third floor of the home was a ballroom. Mr. Bennett built a racetrack on the property for training his horses. He was a winner of the 1909 Tennessee Derby. Upon his retirement, Mr. Bennett owned and operated the Ridgeway Dairy from this property. He also traded real estate. This property was later sold and became the Ridgeway Country Club and has now been developed into River Oaks subdivision. The boundaries of this property are Massey Road on the east, Shady Grove Road on the north, Interstate 40 on the west, and Quince Road on the south.

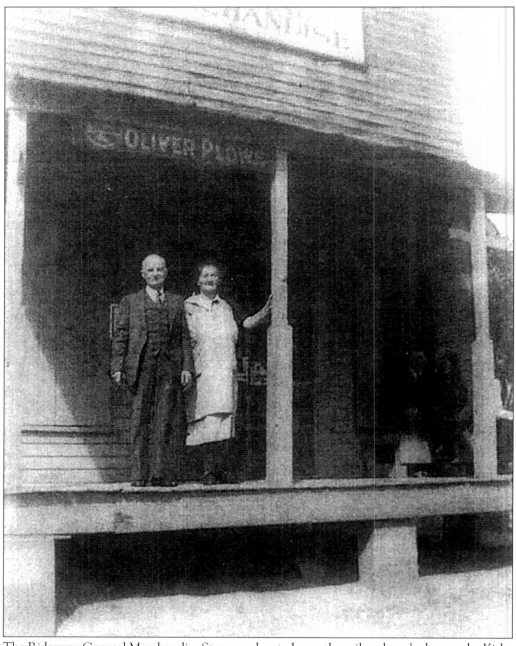

The Ridgeway General Merchandise Store was located near the railroad track close to the Kirby Farm. Notice the old Oliver Plow sign, *c.* 1935.